the best of

brochure 4 design

First published in the United States of America by:
Rockport Publishers, Inc.
33 Commercial Street
Gloucester, Massachusetts 01930-5089
Telephone: (978) 282-9590
Facsimile: (978) 283-2742

Distributed to the book trade and art trade in the United States by:
North Light Books, an imprint of
F & W Publications
1507 Dana Avenue
Cincinnati, Ohio 45207
Telephone: (800) 289-0963

Other Distribution by:
Rockport Publishers, Inc.
Gloucester, Massachusetts 01930-5089

ISBN 1-56496-376-4
10 9 8 7 6 5 4 3 2 1

Printed in Hong Kong by Midas Printing Ltd.

Design: **Wren Design**
Cover Images: **front cover: (clockwise) see pages 31, 22, 112**
 back cover: (left to right) see pages 140, 79, 97

the best of

brochure 4 design

ROCKPORT PUBLISHERS
GLOUCESTER, MASSACHUSETTS
DISTRIBUTED BY NORTH LIGHT BOOKS
CINCINNATI, OHIO

contents

introduction

Brochures. They are often the first thing a graphic-designer-in-training learns how to design. They are also often what is made when learning the ropes of a new layout software program. It would be a rare case to find a graphic designer with no brochure design in his or her portfolio. But brochures are more than just training tools, and graphic designers are much more than just brochure-makers.

Brochures are currently the most effective way to present information in an accessible, and attractive, format. The definition of a brochure is so loose that designers have almost unlimited design options. From triple-fold sheets to boxes to books, brochures can be on any topic, they may try to advertise, sell, or merely inform. The range of possibilities may account for the tremendous number of different brochures created every year.

There are so many factors to consider when creating a brochure. There is the subject matter, the client's personality, the amount of images and text supplied, and, of course, the budget. Whether it is going to be mailed or set on a shelf plays an important role. Mailed brochures must meet standard packaging restrictions. Brochures on a shelf must stand out against the competitors. Brochures given out by vendors and companies come in every size and shape.

The most important goal of all brochures, though, is to get the attention of the viewer. It must be clear and attractive to the intended audience. A clear message does not necessarily make a memorable brochure. It is the expert eye of the designers that creates a beautiful brochure. Think of the brochures that you or your friend kept from an event you went to, or a place you wanted to go. You may not have identified exactly what design aspect made it unique, but these brochures definitely captured the essence of the event or the company. The ability to embody the spirit of the client in a mere paper brochure is what makes it memorable, and is proof of a good design.

The brochures included in this book show exemplary creativity and good design. The diversity and potential of the included works shows much of the breadth and range of brochures being created today. What are not shown are the new, interactive brochures. More and more often on the World Wide Web you can find these brochures. This new format will increase the potential for innovation, but will never replace traditional brochures. The graphic design world is changing, but those first experiments with design will not stop happening for a long, long time.

welcome

to the

Vineyards

of

NNONIA

product

b r o c h u r e s

Design Firm **Watts Graphic Design**
Art Directors/Designers **Helen Watts,
Peter Watts**
Tools **Macintosh**

*The clean, corporate feel to this paper
made the designers think of a clean
photographed solution. The unique layout
and form cutting makes this paper product
brochure a winner.*

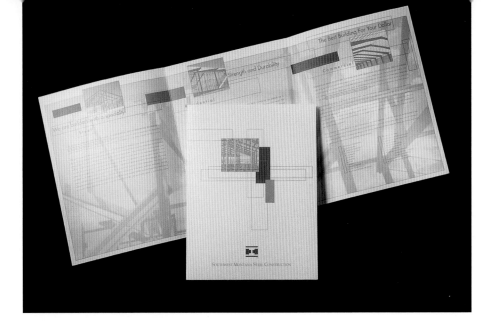

▶

Design Firm **Palmquist and Palmquist**
Art Directors/Designers **Kurt Palmquist,
Denise Palmquist**
Photography **Bill Bishop**
Copywriter **Joanne Wilke**
Client **Southwest Montana Steel Construction**
Tools **Adobe PageMaker, Adobe Illustrator**
Paper/Printing **Star White Vicksburg/
Two-color offset**

*The goal was to create a promotional piece that com-
pared wood and steel, and showed how steel can be
used in homes as well as in commercial applications.
One unique challenge was to use existing snapshots of a
building-in-progress provided by the client.*

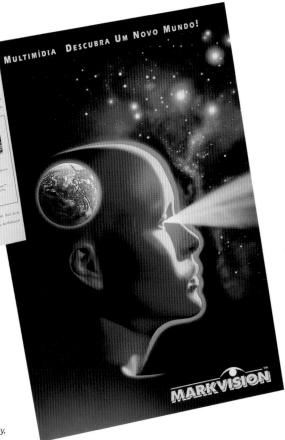

▲

Design Firm **Reiser and Reiser**
Art Director **Tino Reiser**
Designer **Ramon Garcia**
Copywriter **Nahyr Acosta**
Client **Markvision, Inc.**
Tools **Adobe Photoshop, QuarkXPress**
Paper **100 lb. enamel gloss**

*Existing product shots, stock photography,
and original illustrations were used to
portray client's Surround Sound products
in a highly futuristic manner. The primary
challenge was the tightness of the
schedule—the brochure was developed in
under two weeks for distribution at
Comdex/Hispanoameria '96.*

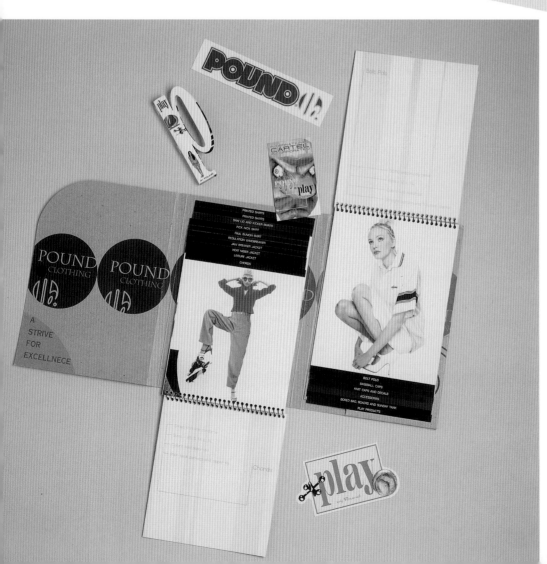

Design Firm **Erbe Design**
Art Director/Designer **Maureen Erbe**
Photography **Henry Blackham**
Copywriter **Erbe Design**
Client **Race Ready**
Tools **QuarkXPress**
Paper **Jefferson 80 lb. matte**

This brochure was designed as a direct-mail catalog for a company that sells running clothes. The concept was to sell the clothes by selling the image of the company. Interesting copy and photography establish the clothes as useful to the serious amateur athlete.

RACEREADY

Go ahead! You're ready.

THE VOICE INSIDE YOU KEEPS YOU PUSHING. You train. You work hard. YOU DO THE BEST YOU CAN DO. Go ahead. You can do it. YOU KNOW YOU ARE READY. IT'S THE BEST RACE OF ALL. THE RACE AGAINST YOURSELF. GO AHEAD. YOU CAN DO IT. YOU'RE READY. RACEREADY.

1995 catalog

Design Firm **9Volt Visuals**
Art Director/Designer **Bobby June**
Photographer **Jason Nadeau**
Client **Pound Clothing**
Tools **Adobe Photoshop, Adobe Illustrator**
Paper **Chipboard**

Created strictly for promotional use only, high-end models were made to look like they were wearing the client's clothing. The piece was produced on a tight budget and a chipboard cover was used to complete the effect.

Design Firm **D-Sign House**
Art Director **Kerstin Bach**
Designers **Kerstin Bach, Sue Hoffman**
Photos **Nattelie Scheurre**
Client **Pannonia Wines**
Tools **Macintosh, QuarkXPress, Adobe Photoshop, Adobe Illustrator**
Paper/Printing **Champion Carnival/ Two-color offset**

The piece was created as a folder with inserts in order to give flexibility as to which wines are to be showcased or are available. Also, the separated pieces allowed a great range of colors while keeping each piece to two colors.

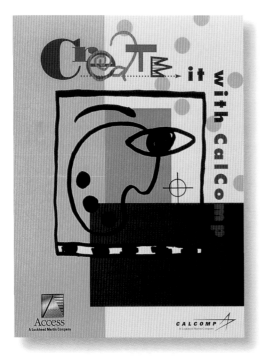

Design Firm **Lee Reedy Creative**
Art Director **Lee Reedy**
Designer/Illustrator **Heather Haworth**
Client **Access Graphics**
Tools **QuarkXPress**
Printing **Four-color process**

*This sales literature was created to promote the
creativity offered by Calcomp's new printer.*

▶

Design Firm **Metalli Lindberg Advertising**
Creative Directors **Lionello Borean, Stefano Dal Tin**

*In repositioning the communications for a company
that produces components for office chairs, the task
was carried out by analyzing the specific issue and
developing solutions that are both technically clear
and esthetically pleasant.*

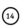

Design Firm **Kanokwalee Design**
Art Director/Designer **Kanokwalee Lee**
Illustrator **Franklin Hammond**
Copywriter **Stephanie Lain**
Client **Btrieve Technologies**
Tools **QuarkXPress, Adobe Illustrator**
Paper/Printing **Warren Lustro gloss/
Offset printing**

*This business-to-business promotional brochure was produced to
get another software company to sign up for support and training.
The piece was produced in six different languages. Many four-color
shell versions of the piece were printed and then later overprinted
in black with differing text depending on the need.*

ELECTRONIC CALCULATORS

1997 FULL LINE CATALOG

SHARP

BASIC

SEMI-DESKTOP

PRINTING

SCIENTIFIC

SPECIALTY

RETAIL

Design Firm **Sharp Electronics Corp.
USA Design Center**

Art Directors **Kim Berlin,
Bruce Goldenstein**

Designer **Kim Berlin**

Illustrator **Kim Berlin**

Photography **Rusty McMillen**

Copywriters **Tony Titone, Glen Gillen**

Client **Sharp Electronics**

Tools **Macintosh 9500, QuarkXPress,
Adobe Illustrator, Adobe Photoshop**

Paper **Cover, Beckett RSVP; text,
Zanders mega dull**

*The objective was to create a functional yet
appealing brochure to shed new light on a very
familiar product. The use of the hand motif and
tactile cover stock reflects the very personal and
tangible qualities of the calculators.*

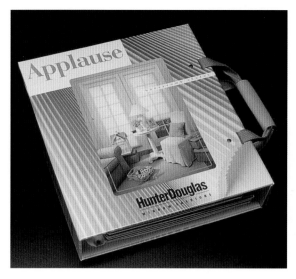

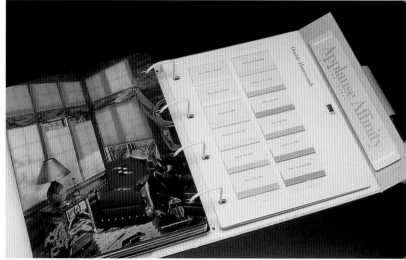

Design Firm **Lee Reedy Creative**
Art Director **Lee Reedy**
Designer **Heather Haworth**
Photography **Nicholas DeScolse**
Copywriter **Carol Parsons**
Client **Hunter Douglas**
Tools **QuarkXPress**
Printing **L and M Printing**

*This sample book for the Applause line of pleated
shades shows light, bright colors with interactive devices
to appeal to designers and buyers.*

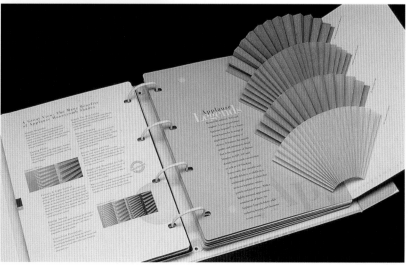

Design Firm **Robert Bailey Incorporated**
Art Director/Designer **Dan Franklin**
Illustrator **Katie Doka**
Copywriter **Robert Bailey**
Client **Boyd Coffee Company**
Tools **QuarkXPress, Adobe Photoshop,
Macromedia FreeHand**
Paper/Printing **Housegloss/Ad Print**

*The purpose of this brochure was to support a newly
designed brand as well as offer insight to the many uses
of flavored Italian syrups.*

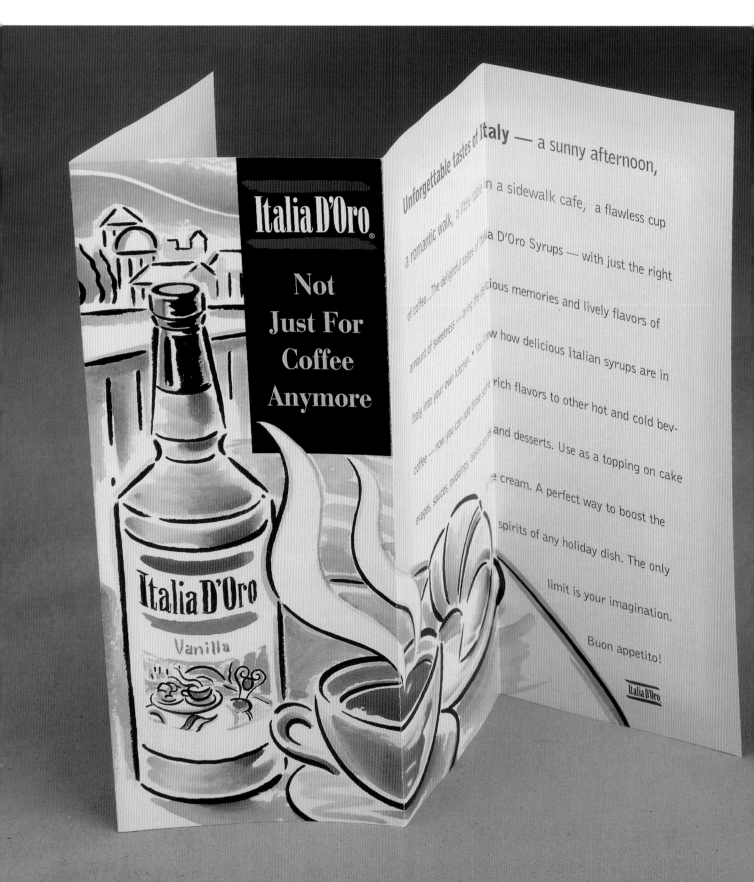

Design Firm
Robert Bailey Incorporated
Art Director/Designer
Dan Franklin
Illustrator
Katie Doka
Copywriter
Michael Hoye
Client
FlavorLand Foods, Inc.
Tools **QuarkXPress,
Adobe Photoshop**
Paper/Printing
**Simpson Evergreen Birch/
Irwin-Hudson**

*The purpose of this brochure
was to promote the virtues of frozen
fruit first and FlavorLand second.
It was meant to display in a rack as
well as hang like a poster.*

Frozen fruit: fast and healthy, wild and wise!

AROUND AND AROUND WE GO.

Around the clock and around the calendar, Flavorland frozen fruits can give your family all the nutritional benefits of a 100% natural food. Regardless of the time of day, regardless of the weather or the season, the all natural goodness of fruit is as handy as your freezer.

Be a good mixer! Chill out with a fruit salad. Or heat things up with a tasty compote. All you need is a bag of Berry Bonanza or Deluxe Mixed Fruits.

PEAK EXPERIENCE.

Naturally ripened fruit gives you the true taste and goodness that Nature intended. With processing plants near our fields and orchards, Flavorland fruits are picked at the peak of flavor and nutrition — not picked green and forced to ripen in transit.

WASTE NOT. WANT NOT.

Frozen fruit is entirely edible. No rinds. No cores. No skins to pay for and throw away. Besides saving you time and trouble this makes frozen fruit's dependable year-round pricing an even better value. So you can afford the fresh choice of fruit regardless of the season.

To top it all off! Peaches on morning cereal. Blueberries on waffles. Strawberries on vanilla ice cream. Boysenberries on yogurt.

THE SECRET OF BEING WELL PRESERVED.

We don't need sugar to make our fruit flavorful. At Flavorland we flash-freeze each berry or piece of fruit individually. When you thaw our frozen fruits, you get the color, taste and texture of hand-picked fruits and berries. Not a frozen mass of fruit and syrup.

A FEW HOT TIPS.

Buy frozen fruits the last thing before checking out and unpack them first when you get home. Before you buy, check each package for clumping. Fruits and berries should flow freely. Clumping means that the fruit has thawed after processing and re-frozen. For maximum freshness set your freezer to 0° F or lower and check it periodically with a freezer thermometer.

TAKE THE EASY WAY OUT.

Everybody wants good nutrition, but who has time to do all the work? Let Flavorland do it for you. Versatile frozen fruits are cleaned and ready to use right out of the bag. Fruit makes an easy and wholesome alternative to fat-laden snack foods.

Guilt free snack! Skip the chips. Try a grape or a slice of peach right out of the bag. No fat. No added salt. But loaded with Vitamin C. They're positively virtuous.

Let them eat cake! And have them begging for more. Raspberries bring out the royalty in a chocolate cake. Dark sweet cherries make a princely Jubilee!

IT TAKES ALL KINDS.

Variety of foods is a key to good nutrition as well as the spice of life. Nutritional experts recommend 2 to 4 helpings of fruit every day. The wide variety of Flavorland frozen fruits makes it easy and economical to please your family and get them the good nutrition they need.

Your finger in every pie! How about cherry, blueberry and boysenberry for openers? Then maybe raspberry or peach? And for the finale? Strawberry-rhubarb, of course!

UNLEASH THE POWER OF THE PYRAMID.

The USDA puts the 5 major food groups in a pyramid that shows how much and how often they should be eaten for optimal nutrition. Fruit is a foundation player in good health. It gives you plenty of vitamins and fiber without fat or added sugar. Frozen fruits are a wholesome and fun alternative to high fat snacks and desserts.

Shake it up! Mix frozen fruit, yogurt, a banana and milk or juice in your blender for a sensational smoothie. For a rich shake, add a scoop of ice cream.

THE FOOD GUIDE PYRAMID.

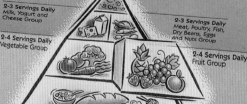

Use Sparingly
Fats, Oils and Sweets

2-3 Servings Daily
Milk, Yogurt and Cheese Group

2-4 Servings Daily
Vegetable Group

2-3 Servings Daily
Meat, Poultry, Fish, Dry Beans, Eggs and Nuts Group

2-4 Servings Daily
Fruit Group

6-11 Servings Daily
Bread, Cereal, Rice and Pasta Group

The sweet life! Naturally.

FLAVOR LAND USA

The sweet life! Naturally.

Fresh facts about frozen fruit.

Design Firm **Hornall Anderson Design Works, Inc.**
Art Director **Jack Anderson**
Designers **Jack Anderson, Bruce Branson-Meyer, Larry Anderston**
Copywriter **Pamela Mason-Davey**
Client **Novell, Inc.**
Paper/Printing **Warren Lustro dull/ Grossberg Tyler**

This corporate identity brochure was designed to serve as an internal piece containing rationale for use and treatment of the Novell identity. The standards bring a warm and friendly meaning to the Novell identity. Photo images were used to illustrate the connecting of people-to-people, emphasizing the human element of technology.

VERSION 1.0

IDENTITY

Corporate Identity
GUIDELINES

Novell

The Corporate Signature

The corporate signature consists of two elements: the "N" design and the logotype. The examples shown here are two color versions. It is preferable to use these versions whenever possible.

There are two formats for the signature: vertical and horizontal. Two versions are provided to allow for proper display in a variety of applications.

The signature is designed as a single unit. All elements of the signature must be used as shown.

The logotype may be used alone. The "N" design, however, must always be accompanied by the logotype.

Novell® Vertical signature

Novell® Horizontal signature

Novell® Logotype only

scope

Throughout the world, across many cultures, elements and images used

Global

consistently connect everything we do.

Novell®

▲

Design Firm
Wolfram Research Creative Services
Art Director **John Bonadies**
Designers **John Bonadies, Jody Jasinski**
Illustrator **Michael Trott**
Copywriter **Stephen Wolfram**
Client **Wolfram Research, Inc.**
Tools **Mathematica, Adobe Illustrator, Adobe Photoshop, QuarkXPress**
Paper **Warren 70 lb. dull**

This brochure's purpose is to communicate, in a manner that is comprehensive as well as easily understood, the features and extensive functionality of Mathematica 3.0, a fully integrated technical computing software package.

WOLFRAM RESEARCH

A First Look At
MATHEMATICA®
3.0

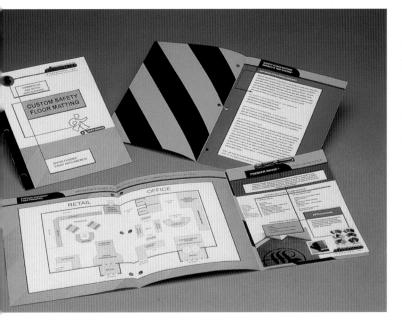

◄

Design Firm
Sayles Graphic Design
All Design
John Sayles
Copywriter
Wendy Lyons
Client
Sbemco International
Paper/Printing
Springhill/Offset printing

As part of an ongoing identity campaign, the piece features the Step Ahead theme. The piece includes the use of the company's trademarked fuchsia and teal backing. Designed to be flexible, the catalog has a metal fastener which attaches individual pages with details on specific product lines.

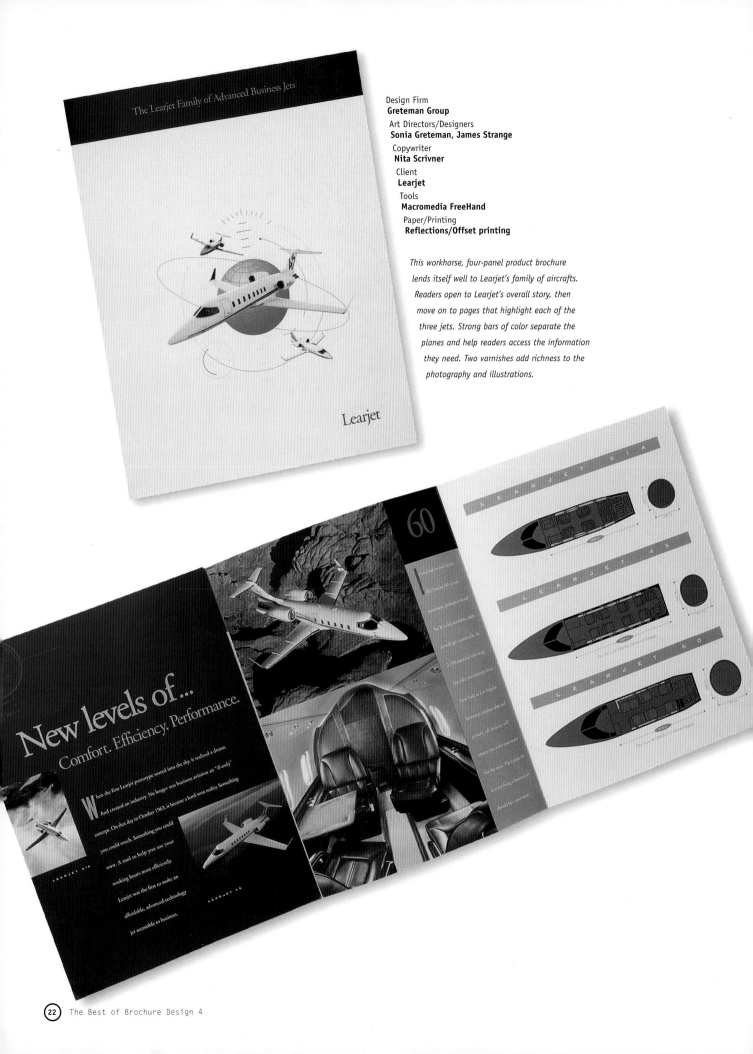

The Learjet Family of Advanced Business Jets

Learjet

Design Firm
Greteman Group
Art Directors/Designers
Sonia Greteman, James Strange
Copywriter
Nita Scrivner
Client
Learjet
Tools
Macromedia FreeHand
Paper/Printing
Reflections/Offset printing

*This workhorse, four-panel product brochure
lends itself well to Learjet's family of aircrafts.
Readers open to Learjet's overall story, then
move on to pages that highlight each of the
three jets. Strong bars of color separate the
planes and help readers access the information
they need. Two varnishes add richness to the
photography and illustrations.*

New levels of...
Comfort. Efficiency. Performance.

Design Firm **Brevis/KD Computer Graphics**
Art Director **Ralf Baumer**
Designer **Klaus-Dieter Nagel**
Client **Siemens Nixdorf**
Tools **CorelDraw, Adobe Photoshop**
Printing **Offset**

*The brochure describes the Middleware solution from Siemens
Nixdorf, the largest European IT manufacturer. It was totally
designed by using CorelDraw and Photoshop.*

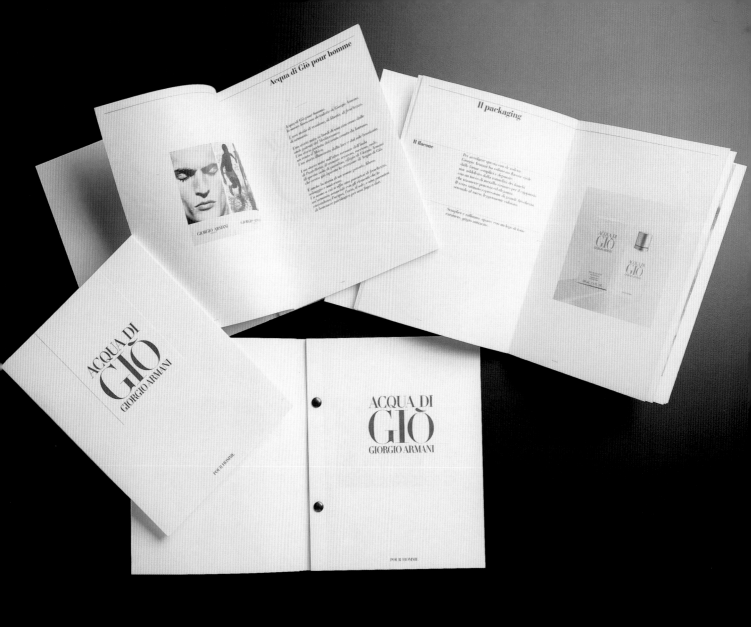

Design Firm **Giorgio Rocco Communications**
Art Director/Designer **Giorgio Rocco**
Client **Giorgio Armani Parfums**
Tools **Macintosh, Adobe PageMaker,
Macromedia FreeHand**
Paper/Printing **Colors/Fedigoni 300 gm paper/
Four-color process plus one PMS**

*This brochure was printed using four-color process with embossed
simulation to give emphasis to the brand logotype. The pages have
been tied with circular dark-gray metal buttons that key the special
fifth color used within the brochure.*

Design Firm **Department 058**
Art Director/Designer **Vibeke Nodskov**
Client **Leo Pharmaceuticals**
Paper **Royal Consort 200 gm silk**

The brochure required great attention from the printers,
both in respect to the die cut and gluing as well as the
spot varnish on both the cover and the interior.

SOM MONETS HAVE

-en klassiker, der bevarer sin værdi over tiden

Pondocillin® pivampicillin

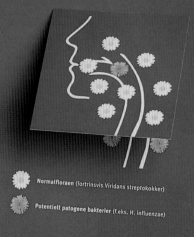

FLORAEN ER VÆRD AT KÆMPE FOR...

Normalfloraens funktion er at beskytte mod fremmede mikroorganismer [1]

Normalfloraen (fortrinsvis Viridans streptokokker)

Potentielt patogene bakterier (F.eks. H. influenzae)

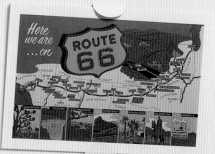

Design Firm **Sibley/Peteet Design**
Art Director/Designer **Don Sibley**
Client **Weyerhaeuser Paper Company**
Paper/Printing **AZ Dryography**

This brochure for Weyerhaeuser Paper Company promotes their Cougar Offset grade and is part of an ongoing series entitled, "American Artifacts." The piece features several special techniques including a pop-up set of vintage postcards on the cover and pull-out style on the inside. The job was printed using the Dryography (waterless) printing process.

make an impact

Impact™ is the absolute finest dark tanning lotion Supre has ever created, designed specifically for tanners who demand the very best that money can buy and who are extremely conscious about the health of their skin.

Maximize Tanning Results
Impact is enriched with maximum levels of Zinc, Copper, Magnesium, Calcium, and Uniperton VEG-2002 allowing your skin to achieve the deepest, richest, most golden tan attainable in the shortest time possible.

Recover From UV-Light Exposure
Impact contains our revolutionary Skin Recovery System™, to help stimulate the skins natural ability to recover from UV-light exposure.

Minimize The Look Of Fine Lines And Wrinkles
Vitamins A, E, and C are free radical scavengers that help neutralize environmentally triggered oxidants before they can damage the skins appearance and minimize the look of fine lines and wrinkles.

Design Firm **Swieter Design U.S.**
Art Director **John Swieter**
Designers **Mark Ford, Julie Poth**
Illustrator **John Morrison**
Copywriter **Bruce West**
Client **Supre**
Tools **Adobe Illustrator, Adobe Photoshop, QuarkXPress**

This piece served as a brochure, cata-log, and promotional magazine to highlight the 1997 Supre product line. The focus was on positioning the products with an attitude and lifestyle to body-conscious people.

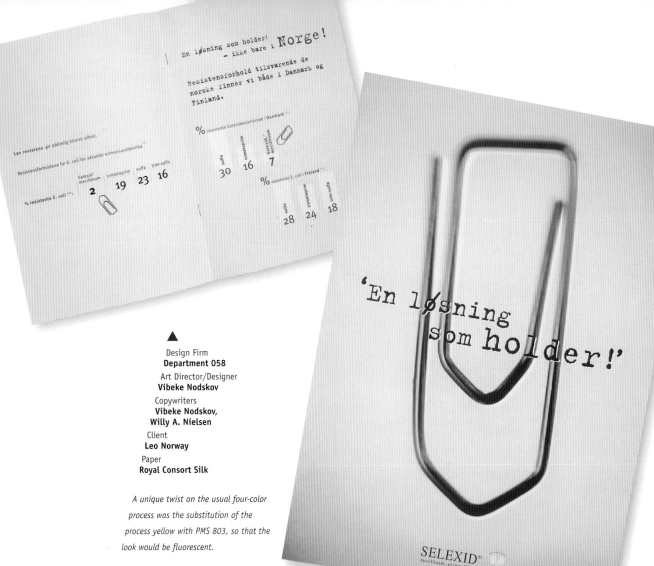

En løsning som holder!
– ikke bare i Norge!

Resistensforhold tilsvarende de norske finner vi både i Danmark og Finland.

Lav resistens gir pålitelig klinisk effekt.

Resistensforholdene for E. coli for aktuelle urinveisantibiotika.

Selexid mecillinam	trimetoprim	sulfa	trim-sulfa
% resistente E. coli			
2	19	23	16

% resistente Enterobacteriaceae i Danmark

sulfa	trimetoprim	Selexid mecillinam
30	16	7

% resistente E. coli i Finland

sulfa	trimetoprim	trim-sulfa
28	24	18

'En løsning som holder!'

SELEXID®
mecillinam, pivmecillinam

▲

Design Firm
Department 058
Art Director/Designer
Vibeke Nodskov
Copywriters
**Vibeke Nodskov,
Willy A. Nielsen**
Client
Leo Norway
Paper
Royal Consort Silk

A unique twist on the usual four-color process was the substitution of the process yellow with PMS 803, so that the look would be fluorescent.

◄

Design Firm
Toni Schowalter Design
Art Director/Designer
Toni Schowalter
Client
Johnson and Johnson
Tools
**Macintosh, QuarkXPress,
Adobe Illustrator,
Adobe Photoshop**

A square format, graphic cropping of images with metallic inks, and duotones create interest in this barrel-folded brochure for Johnson and Johnson. The piece compares the value of this division with the consumer-products division.

NEW GENERATION
FINE HIGH BRIGHTNESS
COATING CLAYS
FROM ECC INTERNATIONAL

ECC International

Design Firm **Bluestone Design**
Designer **Ian Gunningham**
Illustrator **Symon Sweet**
Client **ECC International**
Tools **Macintosh**
Printing **Lithography**

*The client's product is
a new, super high-brightness
clay-coated paper. The design
needed to communicate gloss,
speed on print run, quality,
and high performance. Hence,
the use of winter time images.*

paper

gloss

Advanced pigment engineering techniques have been used to produce fine particle size products which increase paper gloss and maintain the high deltagloss, or "snap", characteristic of English clays which is particularly appropriate for the production of high quality silk and matt papers.

Paper Gloss /
Litho Ink Gloss

*60 gsm LWC
offset coat
weight 10 gsm
Latex/CMC
formulation*

print

gloss

The new generation English clays give excellent coating holdout and retain very good coverage properties which contribute to excellent offset print performance. This is both in terms of dry/litho print density and a well-controlled ink setting rate.

Ink Setting Rate (10s)

*60 gsm LWC
offset coat
weight 10 gsm
Latex/CMC
formulation*

Litho Print Density

*60 gsm LWC
offset coat
weight 10 gsm
Latex/CMC
formulation*

SEE THE WORLD IN A NEW LIGHT

Design Firm
Melissa Passehl Design
Art Director
Melissa Passehl
Designers
Melissa Passehl, Charlotte Lambrechts, David Stewart, Christopher Passehl
Client
Viewmate

The design objective was to create an over-all new product brochure that conveyed the company's commitment to quality color monitors. The company's attention to detail, precision, and color were used as design elements in the folder through debossed, playful color, and a unique die cut.

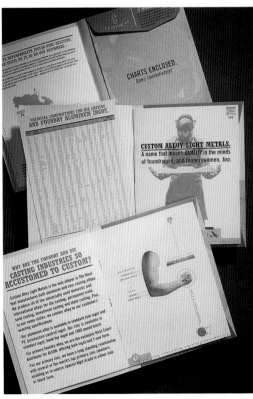

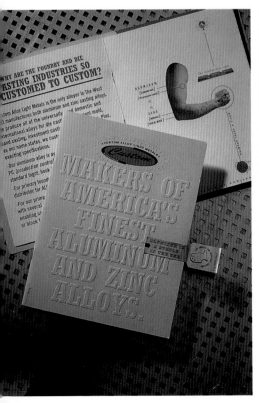

Design Firm
Labbe Design
Art Director/Designer
Jeff Labbe
Illustrator
CSA Archive
Copywriter
Eric Springer
Client
Custom Alloy Light Metals
Tools
Adobe Illustrator, QuarkXPress
Paper/Printing
French Paper Co./Five PMS colors

This brand brochure for a company that takes the scrap metal and manufactures it into a useable commodity pays tribute to those bygone days of the booming metal industry. The brochure educates the reader about the company and provides an order sheet. No trapping was involved, and two colors were custom mixed.

Design Firm
Di Luzio Diseño
Art Director/Designer
Hector Di Luzio
Client
Silisol S.A.
Paper/Printing
Coated paper/Offset printing

*This brochure had to unify a whole line of products with
different identities to communicate umbrella brand
quality. The colors of the brand were used so that they
had as much emphasis as the products.*

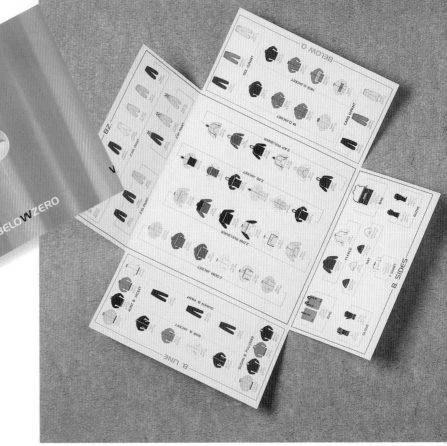

Design Firm **Mason Charles Design**
Art Director/Designer **Jeffrey Speiser**
Illustrators **Design Works,
Jeffrey Speiser**
Copywriter **Kim Kovel**
Client **Belowzero**
Tools **QuarkXPress,
Adobe Illustrator,
Adobe Photoshop**
Paper/Printing **Valorem 65 lb.
opaque vellum/Job Parilux**

*Each year, the client prints a brochure
highlighting its winter clothing line. This
year a design was proposed that would involve
creating a plus-fold brochure. In order to include
pricing, descriptions, and trade show schedules,
a square was inserted that could be customized,
depending on the recipient.*

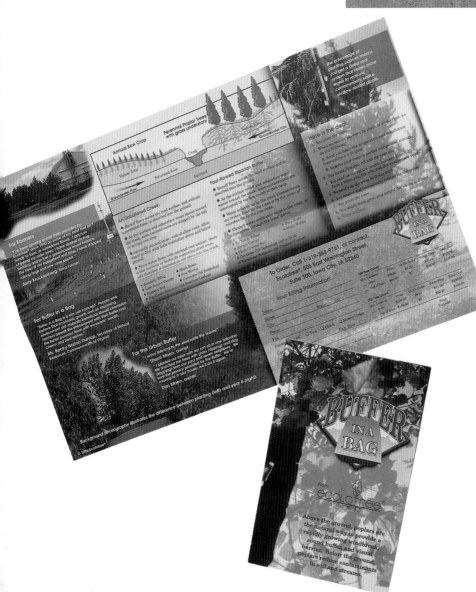

Design Firm **Marketing and
Communications Strategies, Inc.**
Art Director **Lloyd Keels**
Designer **Eric Dean Freese**
Illustrators **Eric Dean Freese, Lloyd Keels**
Copywriter **Simone Grace**
Client **Ecolotree**
Tools **Power Macintoish 8100,
Adobe Photoshop, Adobe Illustrator,
QuarkXPress**
Paper/Printing **Cougar 100 lb. smooth/
Four-color offset**

*The client, Ecolotree, needed a brochure to
promote its product, Buffer in a Bag, a system
to mail-order trees. The client needed the
brochure to include full-color photos of its
products' applications plus an order form.
From start-to-finish, including scans and creat-
ing the Buffer-in-a-Bag logo, the entire
brochure was designed in one 14-hour day.
Knowing that the time constraint would be an
obstacle, the hard-to-reach client put most of
the editorial responsibility on the MCS staff.
The printing was turned around in record time,
and the client was ecstatic about how quickly
the piece was completed.*

Design Firm **Hornall Anderson Design Works, Inc.**
Art Director **Jack Anderson**
Designers **Jack Anderson, Lisa Cerveny,
Suzanne Haddon**
Illustrator **Mits Katayama**
Copywriter **Suky Hutton**
Client **Jamba Juice**
Paper/Printing **Simpson 65 lb. Sundance/Lithographix**

The Jamba Juice Company is a leading retail purveyor of blended-to-order smoothies, fresh-squeezed juices, and health snacks. To communicate the client's objective, a palette of bright colors that appear throughout the stores and their collateral materials was used.

Design Firm **Pensare Design Group Ltd.**
Art Director **Mary Ellen Vehlow**
Designer **Camille Song**
Illustrator **Tim Flynn**
Client **World Bank**
Tools **QuarkXPress, Adobe Photoshop,
Macromedia FreeHand, Adobe Illustrator**
Paper/Printing **Cover: Phoenix Imperial 110 lb./
Four-color process**

*The purpose of this brochure is to inform and promote global bonds
to the Japanese market. The challenge was to present the visual
information without offending any of the represented countries and
without any supplied art.*

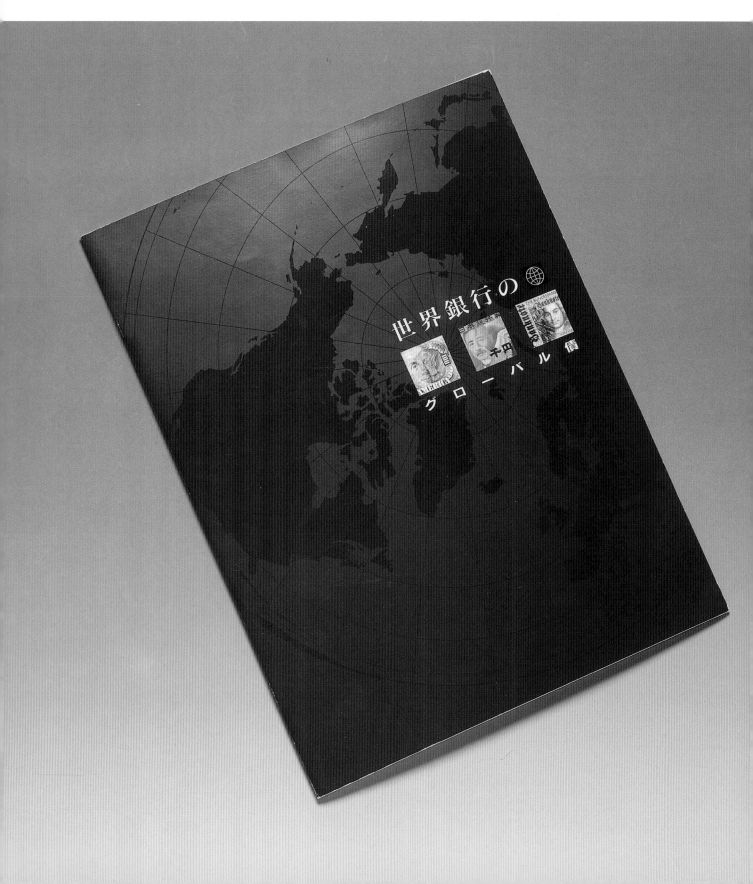

Design Firm **Sibley/Peteet Design**
Art Director/Designer **Don Sibley**
Client **Weyerhaeuser Paper Company**

*This series of brochures for Weyerhaeuser Paper
Company promotes their Cougar Offset grade and is part
of an ongoing "American Artifacts" campaign. The piece
is geared toward graphic designers and printers, and
focuses on innovative printing techniques.*

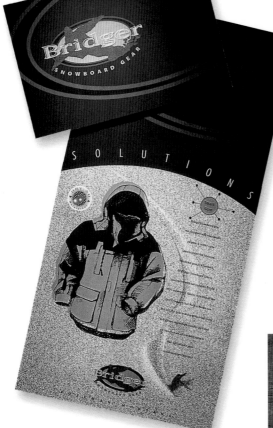

▲

Design Firm
Palmquist and Palmquist

Art Directors/Designers
**Kurt Palmquist,
Denise Palmquist**

Illustrators
Selisa Rausch, Kurt Palmquist

Copywriter
Joann DeMeritt

Client
Bridger Snowboard Gear

Tools
Adobe Illustrator

Paper/Printing
Productolith Dull/Four-color process

The goal was to create a piece that would set Bridger Snowboard gear apart from the more funky snowboard wear companies. The designers focused on the functionality of the outerwear while still keeping in step with style.

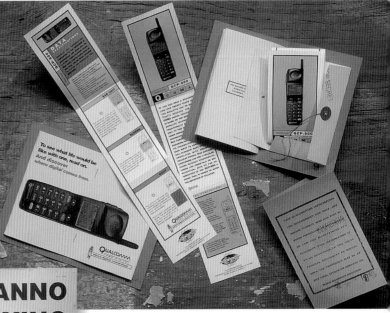

▲

Design Firm **Labbe Design**
Art Directors **Jeff Labbe, Jon Gothold**
Designers **Jeff Labbe, Marilyn Louthan**
Illustrator **CSA Archive**
Copywriters **Eric Springer, Ed Crayton**
Client **Qualcomm Inc.**
Tools **Adobe Illustrator, QuarkXPress**
Paper/Printing **French Paper Co.**

The challenge of the project was to make the reader aware of the problems of analog cellular phones and the vast improvement of digital cellular. By breaking down the communication through a number of pages, the reader has to struggle through an analog conversation. The brochure uses a secret/official theme that plays upon the fact that this technology was first used by spies in the 1940s. The pocket envelope contains a spec card that explains the new QCP-800.

Design Firm **Juice Design**
Art Director **Tery Young**
Designer **Brett M. Crithlow**
Copywriter **Jon Schleuning**
Client **The Northface**
Paper **Simpson Coronado 80 lb.
White Stipple**

*This brochure was designed for the
North Face's Freeport, Maine store.
Its function was to advertise the
store's location while offering local
spots to test the gear out.*

rob hutchingson climbing in zion. photo: jim thornburg

For thirty years, athletes whose lives depend on the performance of their

gear have consistently chosen The North Face. We carry the expedition-proven

tents, packs, sleeping bags, technical outerwear, skiwear and performance

clothing that are the choice of the world's finest mountaineers, skiers and adventurers.

You'll find technical outdoor clothing and equipment, plus savings up to 60% on

discontinued merchandise, seconds and overruns. All of our products are backed with

The North Face Lifetime Warranty. You don't have to go far to get away.

Come to the store. Then please, go away.

While you're in Freeport, make The North Face your first
stop before heading out to explore the area. Here are a few
local areas for mountain biking, climbing and hiking adventures:

high camp in the ak-su with alex lowe & conrad anker. photo: chris noble.

Camden Hills State Park: Camden, ME (45 miles north of Freeport).
The park offers many miles of great trails to hike, some amazing views of the Atlantic,
and a terrific climbing area known as Maiden's Cliff. For info call 207.287.

Grafton Notch Area: White Mountain Region near Bethel, Maine (2 hou
The Grafton Notch area features some of the most spectacular and rugged hiking
in the Appalachians, including Mahoosuc Notch, rated the most difficult
For more info call the Maine State Information Offi

Sunday River Mountain Bike Park: Bethel, Maine (2 hours northwes
Sunday River's two chairlifts offer access to more than 60 miles o
miles of backroads and logging tracks to explore. For

camping

scot

The North Face is located at 5 Bow Street and Main, Freeport, Maine.

Freeport, Maine

Design Firm **Widmeyer Design**
Art Director/Designer **Dale Hart**
Illustrator **Christopher Downs**
Photography **Landreth Studios**
Copywriter **Seattle Software Labs**
Client **Seattle Software Labs**
Tools **Power Macintosh,
Adobe Photoshop, Macromedia FreeHand**
Paper/Printing **Mead Signature Gloss/
Four-color process**

Seattle Software Labs designs and manufactures Internet and computer-network security products. The gatefold brochure describes the increasing need for Internet and network security for businesses. Single page companion inserts outline specific product features and software options. The inserts were designed to accommodate both 8-1/2" x 11" and A4 formats for domestic and international use.

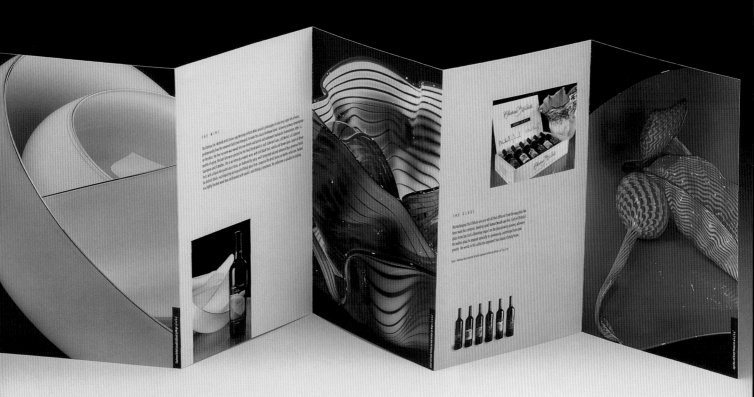

Design Firm **Studio MD**
Art Director/Designer **Randy Lim**
Client **Chateau Ste. Michelle
Vineyards and Winery**
Tools **Macromedia FreeHand,
Adobe Photoshop**
Paper/Printing **Warren Lustro
dull Recycled/Offset printing**

*This brochure announced the
premier of the Chateau Ste. Michelle
"Artist Series" wine collection
featuring internationally acclaimed
artist, Dale Chihuly. Each wine bottle
in the six-bottle collection has a
distinct label that depicts an exquisite
Chihuly glass form. For the brochure,
an accordion fold format was selected
in order to showcase each of artist's
glass sculptures on full-bleed panels.*

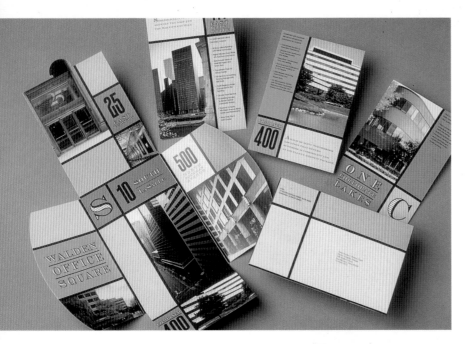

Design Firm
Sayles Graphic Design
Art Director
John Sayles
Designers
John Sayles, Jennifer Elliott
Illustrator
John Sayles
Client
Koll Real Estate
Paper/Printing
Springhill/Offset printing

Designed for Chicago developer Koll Real Estate, this direct-mail piece was designed as a marketing tool for leasing agents with ten single pages that show-case individual properties. The pages are mailed in a die-cut wrap printed with images of the properties.

Design Firm **Mires Design**
Art Director **José Serrano**
Designers **José Serrano,
Deborah Horn**
Illustrator **Joel Nakamura**
Client **Invitrogen Corporation**

The designers created a cover for the client's catalog that had a fresh look without look-ing too high tech.

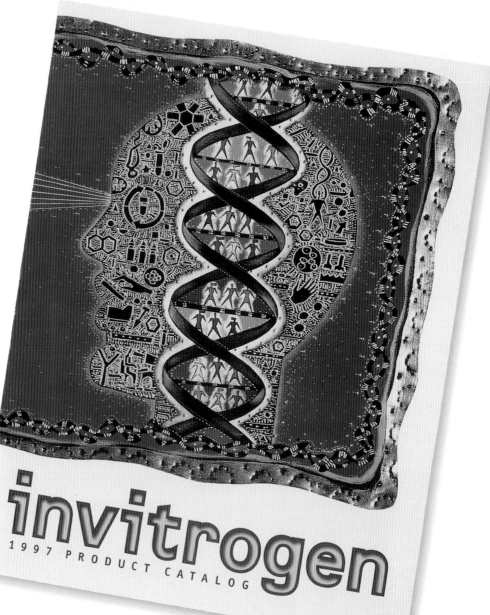

Fermentation or culturing is used to produce familiar foods such as traditional cheeses, wines, and yoghurt, and in a similar way we can culture legumes, seeds or grains, to produce a fragrant firm cake, more digestible than the original, and having a unique, nutty flavour. This product is called 'Tempeh' and was discovered in Indonesia at least 1000 years ago. It is still very popular there as a major protein source. In Australia Tempeh has been growing steadily in popularity as a nutritionally sound meat alternative for vegetarian and health conscious people. More recent... ...urants and lunch bars ...empeh for its delicious ...e.

an increased risk of endometrial and liver cancer (see 'New Scientist', 9th July 1994). This report also indicates that these soya proteins can also inhibit the growth of prostate and colon cancer cells. The report goes on to suggest that fermented Soy products such as Tempeh and Miso may be even more potent than the non fermented foods such as Tofu and Soy Milk. Soy beans are also the natural source of Linoleic acid and Lecithin, which the Medics. tell us help to keep our arteries clear of plaque, and are very low in saturated fats and starch, making Tempeh ideal for special diets. Tempeh is also an excellent source of Calcium, Iron and 'B' vitamins.

...and you can use Tempeh to replace meat in most meat recipes. There is no waste, no gristle, fat or bone to discard, and it can be stored frozen for months.

So although Tempeh is of ancient origin, it is a perfect modern food, virtually instant to prepare, and very good for your health.

Vitamins deteriorate progressively with exposure to heat and air, so our Tempeh is supplied in sealed packs, refrigerated or frozen. Because our Tempeh is not pasteurised it is still biologically active on purchase and can actually be used to make your own Tempeh at home (see 'Earth Garden', Sept. 1994). 'Nectar' Tempeh is made in the Central Victorian Highlands away from the city pollution, and the water we use is free of chlorine and fluoride.

If you would like to try 'Nectar' Tempeh, look for the orange pack with the see-through-window. Tempeh that is still fresh will be white and firm and have a clean mushroomy fragrance.

HERE'S A FEW RECIPES TO TRY...

BASIC METHOD...

Cut the Tempeh into slices 7-8mm thick across the block. This will give 20-25 slices per block. Fry in a heavy base pan to medium brown, using light olive oil or grapeseed oil, then drain on kitchen paper. Eat hot and fresh, you can use a favourite sauce as a dip. PTO...

NECTAR TEMPEH
Ancient Food for Modern Times

...gland and ...foods contain ...h can ...ffects, an ...given to ...eloping ...ked to

Design Firm
Mammoliti Chan Design
Art Director
Tony Mammoliti
Designer
Chwee Kuan Chan
Illustrator
Chwee Kuan Chan
Copywriter
Mike Manser
Client
Nectar Soy Products
Tools
Adobe Illustrator
Printing
Three-color offset

A minuscule budget required the use of clip art to generate pictures for the leaflet. The piece was printed on a two-color press using cyan, magenta, and yellow on two stocks.

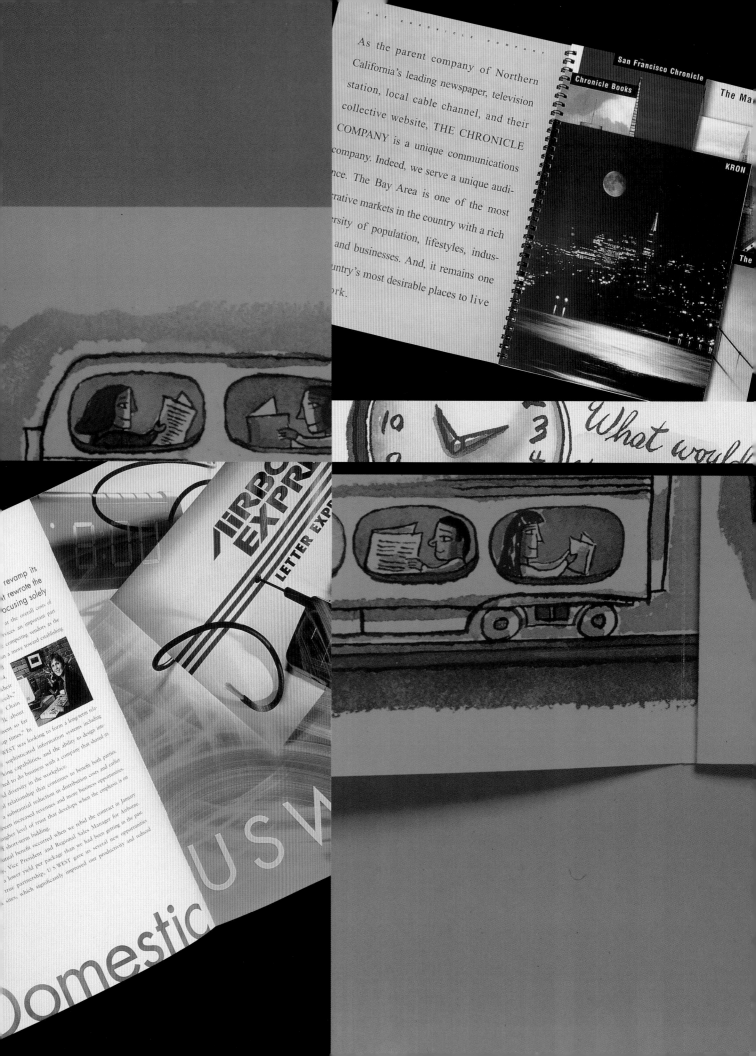

service

brochures

where
the
pavement
stops
chris haines
baja
off-road
tours
begin

Design Firm **Mike Salisbury Communications, Inc.**
Art Director **Mike Salisbury**
Designer **Mary Evelyn McGough**
Client **Chris Haines' Baja Off-Road Tours**
Tools **QuarkXPress, Adobe Illustrator**
Paper/Printing **Duotone 50 lb. text, newsprint aged; Duotone 80 lb. cover, packing gray; saddle stitched-long side/Four-color process**

Primary production was done using Quark and Illustrator. A fluorescent color was added to the front and back to add visual impact to the piece.

The ARTS in Massachusetts

Design Firm **Rose Srebro Design**
Art Director **Rose Srebro**
Designers **Rose Srebro, Chris Clarendon**
Client **Massport**
Tools **QuarkXPress, Macromedia FreeHand**
Paper/Printing **Crosspoint Genesis/Emco Printers**

This guide for tourists visiting Massachusetts offers a listing of entertainment, museums, and art. The primary design consideration was that all information was effectively communicated while being easy to read.

The Best of the Bay State:

A Guide to Cultural Entertainment in

Design Firm **Metalli Lindberg Advertising**
Creative Director **Lioneus Borean, Stefano Dal Tin**
Designer **Owen M. Walters**
Client **Bobadilla Athletic Center**
Tools **Adobe Illustrator, Adobe Photoshop**

This accordion-fold promotional piece for an important fitness center uses several type treatments to catch the viewer's eye. The piece was mailed to clients to promote new courses and activities.

Design Firm **Wdesign, Inc.**
Art Director **Alan Wallner**
Designer **Lisa Hagman**
Copywriter **Sharon Feiner**
Client **Dorholt Printing**
Tools **3M Materials**

*Dorholt Printing needed a brochure that
would highlight their many capabilities
that were unknown in this competitive
market. Now they are competing with
the high-end printers in the area and
business is booming.*

*If you demand
a superior mixture of skill and service,*

we've got the formula.

Design Firm **Design Center**
Art Director **John Reger**
Designer **Sherwin Schwartzrock**
Copywriter **John Roberg**
Client **Spanlink**
Tools **Macintosh, Macromedia FreeHand**
Paper/Printing **Warren Lustro, Olympic Printers**

*Using a light presentation with whimsical graphics, the piece's purpose
is to show a problem with telephones and the solution. A special graphic
is placed in die-cut form on the first page.*

Still **puzzling**
over the age-old
call center
problems **?**

Understaffing

Design Firm
Rickabaugh Graphics

Art Director/Designer
Eric Rickabaugh

Photographer
Paul Poplis

Copywriter
Paul Poplis

Client
Paul Poplis

Tools
Macromedia FreeHand, Adobe PageMaker

Paper/Printing
**Warren Lustro 100 lb. cover/
Four-color process**

*This promotional brochure for a photographer
includes office shots, facility shots, and
portfolio shots. All type and art prints in a
metallic-bronze ink.*

PAUL POPLIS
PHOTOGRAPHY

A
GREAT
PLACE
TO
SHOOT
FOOD

THE KITCHEN

A gleaming commercial quality
kitchen big enough for more than
one stylist (surrounded by clients)
to professionally prepare everything
from fast food to elegant gourmet.

• Expansive flat clear work space.
• More than one hundred cubic
feet of refrigerated storage.
• Over fifty cubic feet of freezer
storage space.
• A top of the line Tappan
kitchen range.
• A Viking commercial grade range complete with six burners, two
ovens, a broiler, and a griddle.
• Cecilware commercial fryer.
• Hobart professional slicer.
• A Duke half sheet commercial
grade convection oven.
• A microwave oven.
• All the tools of the trade.

EDITORIAL

ANNUAL REPORT

FACILITIES

Paul Poplis
photography,
incorporated
was designed and built,
all from the
ground up, as
a great place
for shooting
food.

"Information has no value unless it's in the right hands. Informix's extensible database technology allows us to take the right information, at the right time, and put it in the right place."

Elizabeth Warren,
Director of Strategic Interactive Initiatives
Information Technology Department,
Robertson, Stephens & Co.

INFORMIX-Universal Server

In business, information is not only our best ally, it's the most effective weapon in the company arsenal for managing change, increasing customer satisfaction, and achieving competitive advantage. To stay ahead, organizations need to effectively wield every type of information upon which their business depends— from traditional alphanumeric data to digital and multimedia content such as electronic documents, images and audio to Web-based content to abstract data such as financial time-series, and geospatial information. Access to the right information, when and where it's needed, enables us not only to more effectively manage and grow the business, but also respond to evolving customer requirements and exploit new and emerging business opportunities whenever and wherever they arise.

In short, today's businesses run on all types of information. And now, with Informix, your database will too—any kind of information, any time, anywhere.

Informix

NON-TRADITIONAL/ABSTRACT INFORMATION

If you can imagine it,

you can manage it."

INFORMIX-UNIVERSAL SERVER

Design Firm
Mortensen Design
Art Director/Designer
Gordon Mortensen
Illustrator
John Craig
Client
Informix Software, Inc.
Tools
QuarkXPress

One of the visual features of this piece is an illustrated,
movable wheel that is joined to the front cover by a
grommet. The cover is die cut to reveal portions of the
illustrations on the wheel, and a wire-O binding was used
so that the piece would lay flat.

Design Firm **TGD Communications**
Art Director **Rochelle Gray**
Illustrator **Judy Reed Silver**
Client **Food Marketing Institute**
Tools **QuarkXPress**

This promotional piece for a grocer's convention includes illustrations that were painted using acrylics and line work that was scanned into Photoshop and printed as an overlay on reflective art.

Design Firm **Clark Design**
Art Director **Annemarie Clark**
Designers **Thurlow Wasam, Doug daSilva, Ozzie Paton, Carol Piechocki**
Copywriter **Melanie Wellbeloved**
Client **KRON-TV**
Tools **QuarkXPress, Adobe Photoshop, Adobe Illustrator**
Printing **Indigo printing**

The purpose of this sales piece was to inform media buyers that the client consisted of five independent sources for media placement. One challenge was to maintain each company's separate identity without isolating them from the parent company. This was accomplished by creating a single, spiral-bound brochure that contains a series of unique brochures, each representing one of the five independent companies. Indigo printing process was used to stay within the budget.

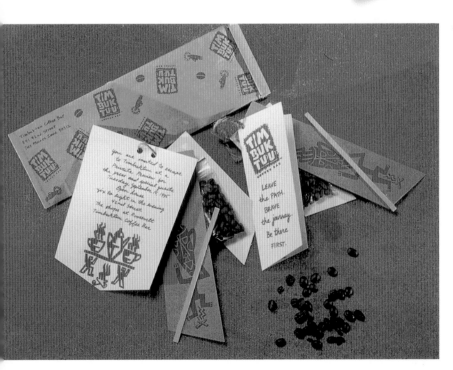

Design Firm **Tom Fowler, Inc.**
Art Director **Thomas G. Fowler**
Designer **Karl S. Maruyama**
Client **Herlin Press**
Tools **QuarkXPress, Adobe Illustrator, Adobe Photoshop**
Paper/Printing **Fox River Confetti/ Herlin Press**

The client needed a promotional piece to demonstrate advantages of direct-to-plate, short-run printing presses versus competing electronic imaging presses.

REAL WATERLESS OFFSET LITHOGRAPHY

THE NEEDLEPRO GTO IS A TRUE WATERLESS OFFSET DIGITAL PRESS. THAT MEANS 8000 IMPRESSIONS PER HOUR AND NO SPECIAL COATINGS NEEDED FOR YOUR PAPER.

REAL STUFF

Design Firm
Sayles Graphic Design
Art Director
John Sayles
Designers
John Sayles, Jennifer Elliott
Illustrator
John Sayles
Copywriter
Annie Meacham
Client
Timbuktuu Coffee Bar
Paper/Printing
Chipboard and Curtis Tuscan Terra/ Screenprinting

For the grand opening of a new coffee bar with a rustic, native atmosphere, the invitation used "leftover" materials for texture and added special effects including a stir-stick and a small bag of coffee beans.

Design Firm **Aerial**
Art Director/Designer **Tracy Moon**
Illustrator (Computer) **Clay Kilgore**
Client **Calypso Imaging, Inc.**
Tools A**dobe Photoshop, Live Picture,**
Adobe Illustrator, QuarkXPress

This series of product and service books for
a Silicon Valley company is designed to
reflect the company's new focus on high-
end, state-of-the-art imaging technology.

Design Firm
Sayles Graphic Design
Art Director
John Sayles
Designers
John Sayles, Jennifer Elliott
Illustrator
John Sayles
Copywriter
Wendy Lyons
Client
Bally Total Fitness
Printing
Four-color offset

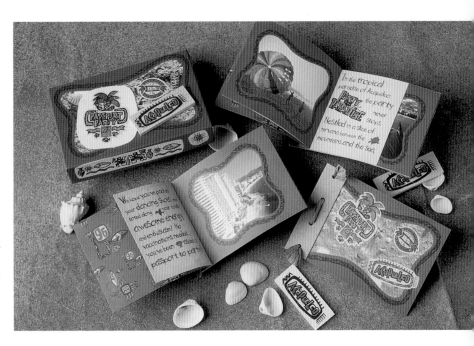

A new brochure for Bally Total Fitness in Acapulco arrives in a graphic, hinge-lid box adorned with screenprinted wood and canvas. The brochure is bound with Kraft raffia; inside pages are different sizes and colors and are printed with graphics that complement the box. The tropical site and associated visuals were incorporated throughout the piece.

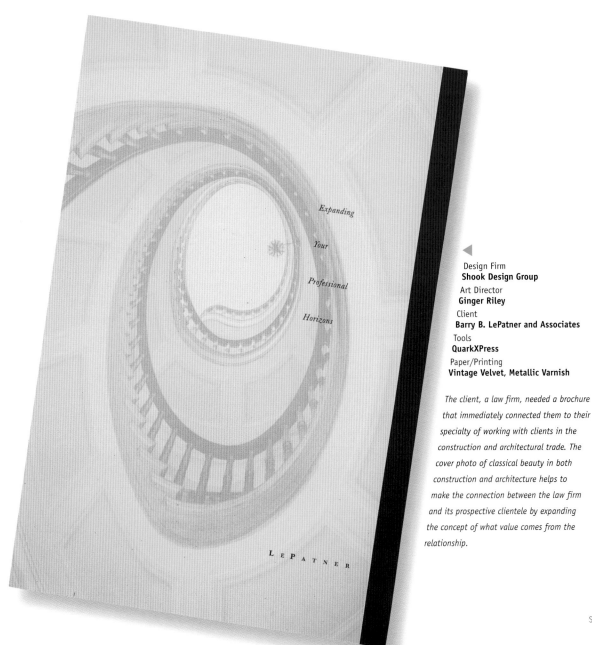

Design Firm
Shook Design Group
Art Director
Ginger Riley
Client
Barry B. LePatner and Associates
Tools
QuarkXPress
Paper/Printing
Vintage Velvet, Metallic Varnish

The client, a law firm, needed a brochure that immediately connected them to their specialty of working with clients in the construction and architectural trade. The cover photo of classical beauty in both construction and architecture helps to make the connection between the law firm and its prospective clientele by expanding the concept of what value comes from the relationship.

see the **Future** now.

MIRA MOBILE TELEVISION

Design Firm **Oakley Design Studios**
Art Director/Designer **Tim Oakley**
Illustrators **Mike Fraiser, Tim Oakley**
Copywriter **Carri Bugbee**
Client **Mira Mobile Television**
Tools **Macintosh**
Paper **Luna Gloss**

a new **vision**

MIRA MOBILE TELEVISION

Design Firm
Words of Art
Art Director/Designer
Sharon Feldstein
Client
Camp Isidore Alterman of the Atlanta Jewish Community Center
Tools
Adobe PageMaker, Adobe Illustrator
Paper/Printing
NW 80 lb. gloss cover/four spot colors

The client needed a summer-camp brochure that would portray fun using color and graphics, but not photos. Angled die cuts and colors effectively separated categories for easy location of information. A separate application was included and mailed in a one-color printed envelope.

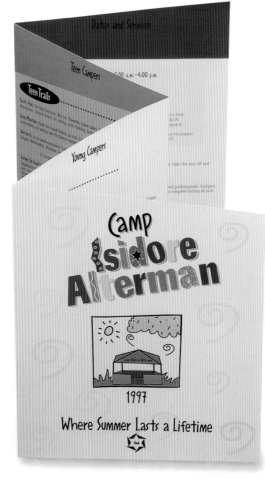

Dates and Services

Teen Campers

Teen Trails

Young Campers

Camp **Isidore Alterman**

1997

Where Summer Lasts a Lifetime

Design Firm **Hornall Anderson Design Works, Inc.**
Art Director **Jack Anderson**
Designers **Jack Anderson, Lisa Cerveny, Jana Wilson, Julie Keenan**
Copywriter **Jeff Fraga**
Client **XactData Corporation**
Paper/Printing **Strathmore Elements, Pin Stripe; Key Lithography**

The primary objective for the XactData identity program was to create a sales piece that appeared technical, yet reader friendly. Initially, the client wanted to include illustrations, but a limited budget kept the program to two colors while illustrations were done in-house.

[XACTDATA]
LAN BACKUP
AND RECOVERY
Keep your data: Safely off-site. **Conveniently on-line.**
Automatically at XactData.

[The trouble with traditional network backup systems] Their data is inaccessible. **They depend on human intervention.** There is no simple, inexpensive way to get the data stored off-site for disaster recovery. **Tape systems are temperamental, mechanical devices.** Tape backup requires time-consuming and unreliable human intervention. **Data retrieval is difficult; immediate access next to impossible.** Hardware is continually made obsolete by advances in technology. **And the list goes on.**

[Introducing a new way to backup network data] A revolutionary way that keeps your data on-line at all times. **A secure way that stores your data safely off-site.** A reliable way that eliminates cumbersome tape backups. **A fail-safe way that has three levels of security.** An innovative way that uses high-speed digital communications. **A convenient way that's automatic and requires no human intervention.** We call it XactData, because it's exactly what you want in a network backup system.

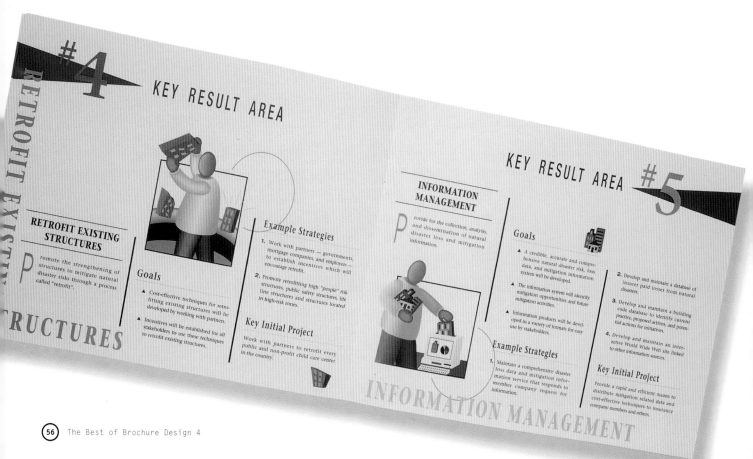

BLUEPRINT FOR ACHIEVEMENT

THE STRATEGIC PLAN
OF THE INSURANCE INSTITUTE
FOR PROPERTY LOSS REDUCTION

SPONSORED BY THE INSURANCE INDUSTRY AND OTHERS COMMITTED TO ACCOMPLISHING OUR MISSION:
"REDUCING DEATHS, INJURIES, PROPERTY DAMAGE, ECONOMIC LOSSES, AND HUMAN SUFFERING CAUSED BY NATURAL DISASTERS."

Design Firm **KBB Communications Design**
Art Director **Jamie Bernard**
Designer/Illustrator **Anna Bemis**
Copywriter **Insurance Institute for Property Loss Reduction**
Client **Institute for Property Loss Reduction**
Tools **QuarkXPress, Adobe Illustrator**
Paper **Warren Lustro 80 lb.**

Created to introduce the company's new strategic plan, this piece fulfills the client's requirements of individual icons to represent key strategic points.

#4 KEY RESULT AREA

RETROFIT EXISTING STRUCTURES

RETROFIT EXISTING STRUCTURES

P romote the strengthening of structures to mitigate natural disaster risks through a process called "retrofit."

Goals

▲ Cost-effective techniques for retro-fitting existing structures will be developed by working with partners.

▲ Incentives will be established for all stakeholders to use these techniques to retrofit existing structures.

Example Strategies

1. Work with partners — governments, mortgage companies, and employers — to establish incentives which will encourage retrofit.

2. Promote retrofitting high "people" risk structures, public safety structures, life line structures and structures located in high-risk zones.

Key Initial Project

Work with partners to retrofit every public and non-profit child care center in the country.

INFORMATION MANAGEMENT

P rovide for the collection, analysis, and dissemination of natural disaster loss and mitigation information.

KEY RESULT AREA #5

Goals

▲ A credible, accurate and compre-hensive natural disaster risk, loss data, and mitigation information system will be developed.

▲ The information system will identify mitigation opportunities and future mitigation activities.

▲ Information products will be devel-oped in a variety of formats for easy use by stakeholders.

2. Develop and maintain a database of insurer paid losses from natural disasters.

3. Develop and maintain a building code database to identify current practice, proposed actions, and poten-tial actions for initiatives.

4. Develop and maintain an inter-active World Wide Web site linked to other information sources.

Example Strategies

1. Maintain a comprehensive disaster loss data and mitigation infor-mation service that responds to member company request for information.

Key Initial Project

Provide a rapid and efficient means to distribute mitigation related data and cost-effective techniques to insurance company members and others.

INFORMATION MANAGEMENT

Design Firm **Barbara Brown Marketing and Design**
Art Director **Barbara Brown**
Designers **Barbara Brown, Darthe Silver**
Copywriter **Annie Hall**
Client **Jim Hall II Kart Racing Schools**
Printing **Inland Litho**

In the past, the client's promotional materials were very corporate in appearance.
Using images related to the client's services, excitement of the sport was brought into
the marketing materials through active colors and metal in the photos and type that
produce the effect of motion.

WHEEL
to
WHEEL
RACING

Tight Turns
Fast
STRAIGHTAWAY
Speed

805 / 654-1329

Easy reservations
805 / 654-1329

Real racers drive fast and smart. Drivers from the exclusive ranks of F-1, Indy Car and NASCAR emphasize kart racing's significance in their careers.

Skill, experience and meticulous training in race dynamics - - - kart racing paves the way for today's young talents world-wide. Local, statewide and national kart races showcase career drivers and weekend warriors.

Instructors at Jim Hall Kart Racing Schools skillfully apply their expertise immediately at your first session - the Introduction to Kart Racing program.

Advanced programs focus on braking points, inside/outside passing lines, developing quick

reaction skills, maintaining a consistent driving line. Preparing you for the decisive split second advantage, JHKRS divides podium finishers from all the rest. Multi-level race instruction is designed to unleash your racing talents, boosting your driving performance.

Karting is the most affordable motorsport today. More than 1,200 racing enthusiasts and skill-seekers per year graduate from Jim Hall Kart Racing Schools. JHKRS are fully sponsored with top of the line sprint and shifter karts and accessories.

Program tuition includes everything...all new race-ready karts, seat time, driver gear, insurance and expert one-on-one training. You benefit from

top professional instruction and lots of track time. Each course includes on-track racing with timed sessions, challenging drills, question and answer periods and a personal performance evaluation. Your only requirement is to be enthusiastic.

Jim Hall II formulates specific driving skills and drills for both the novice and expert racer. Winner of more than 200 kart races, his extensive motorsport credentials include national titles in kart racing to owning and running an Indy Car team. Jim Hall II has set a high standard among all racing schools in the United States.

Design Firm
Design Center

Art Director
John Reger

Designer
John Erickson

Copywriter
Church Metro

Client
Church Metro

Tools
Macintosh, Macromedia FreeHand

Paper/Printing
Lustro/Printcraft

To entice the viewer to take a look inside, the designers used text (representing books) and earphones (for tapes). The goal was to take a serious subject and make it fun.

Design Firm
Polivka Logan Design—PLD

Art Directors/Designers
Chris Adams, Lisa Noreen

Copywriter
Lisa Pemrick

Client
Christian Brother, Inc.

Tools
QuarkXPress

This brochure for a manufacturer of hockey sticks
helps the clients break into a competitive market
with their new product. The piece explains all
products and benefits.

ACROSS

A STARBUCKS STORE IS M

GREAT COFFEE. IT'S A PLA

OR ENJOY THE SWEETNESS O

INSIDE, THE BARISTA COA

THE ESPRESSO MACHINE. T

IRRESISTIBLE AROMA OF C

FRESH SCONES, MUFFINS,

LINE OF LOYAL CUSTOMERS

OF ALL OF OUR VALUED R

6 WITH OUR CUSTOMERS IS M

SHIP OF TRUST THAT'S RE

ON CONSISTENCY OF OUR CO

SERVICE. ON FLEXIBILITY

WAY YOU'D LIKE. AND ON

LIKE THIS: COME IN, YO

THESE ARE THE WORLD'S

THAT THE PRODUCTS ON O

AND FOUND SUPERB; THA

KNOWLEDGEABLE — PASSIONA

WE GENUINELY LOOK FORWARD

11:35 a.m. Starbucks, Brentwood, Los Angeles

Buying whole bean coffee is an adventure at Starbucks. Where else can you explore Java, Guatemala, and New Guinea during lunch? Behind the counter, the barista scoops richly roasted beans from their bins. "Would you like to try our newest arrival, Ethiopia Harrar? Something earthy and smooth like Yukon Blend? Or exotic Sumatra, perhaps — and how would you like that ground?"

The 1994 Journey Together

STARBUCKS
CORPORATION
ANNUAL
REPORT

Design Firm
Hornall Anderson Design Works
Art Director
Jack Anderson
Designers
Jack Anderson, Julie Lock, Mary Chin Hutchinson
Illustrator
Linda Frichtel
Copywriter
Pamela Mason-Davey
Client
Starbucks Coffee Company
Paper/Printing
Graphic Arts Center

The objective for Starbucks' annual report was to develop a revolutionary design that broke with previous years' design theme. Images of a typical store were incorporated as a result of numerous requests from investors, who had never seen a Starbucks store. The piece also needed to educate investors on Starbucks' everyday working philosophies, as well as represent Starbucks' growth through new ventures.

Design Firm
Hornall Anderson Design Works, Inc.
Art Director
John Hornall
Designers
**John Hornall, Lisa Cerveny, Heidi Favour,
Bruce Branson-Meyer**
Copywriter
Elaine Floyd
Client
Airborne Express
Paper/Printing
Warren Lustro Offset, Graphic Arts Center

*In previous annual reports, the client has been
hesitant to establish a theme for the reports.
This year, the designers were allowed to develop
client/Airborne scenarios that demonstrated the
theme of partnership. A close collaboration
between the designers and the client helped to
make to make the report not only an annual
financial report, but also a piece that conveyed
customer stories.*

When a U S WEST subsidiary decided to revamp its transportation and logistics operations, it rewrote the rules on vendor selection. Instead of focusing solely on rates, U S WEST's Business Resources Group decided to look at the overall costs of doing business with its carriers and considered value-added services an important part of the equation. In 1993, it chose Airborne Express over three competing vendors as the company's exclusive express package carrier. Later that year, in a more toward establishing long-term relationships with its suppliers, U S WEST rebid the contract for a three year period beginning January 1994.

"What set Airborne apart from the others was their willingness to tailor their services to meet our needs," said Don Carrington, an area manager of Supply Chain Management for U S WEST. "Many vendors talk about customization but few actually do it. Airborne went so far as to shift established routes to meet our pickup times." In addition to basic transportation services, U S WEST was looking to form a long-term relationship with a carrier that could provide sophisticated information systems including electronic data interchange (EDI) and tracking capabilities, and the ability to design integrated logistics strategies. They also wanted to do business with a company that shared its attitude toward quality improvement and diversity in the workplace.

The result has been a successful relationship that continues to benefit both parties. For U S WEST, the result has been a substantial reduction in distribution costs and earlier delivery times. For Airborne, it's been increased revenues and more business opportunities. Both companies appreciate the higher level of trust that develops when the emphasis is on long-term partnering instead of short-term bidding.

"An example of the mutual benefit occurred when we rebid the contract in January of 1994," said Bob Kelley, Vice President and Regional Sales Manager for Airborne. "The contract called for a lower yield per package than we had been getting in the past. But in the spirit of a true partnership, U S WEST gave us several new opportunities at major distribution sites, which significantly improved our productivity and reduced our overall costs."

**AIRBORNE'S OWN
AIRPORT HOUSES
EXTENSIVE FLEET OF
AIRCRAFT**

Airborne Express is the only overnight delivery service to own its own airport. ABX Air, Inc., a wholly-owned subsidiary of Airborne, maintains a fleet of 105 aircraft and has exclusive take-off and landing facilities at its airport in Wilmington, Ohio. During a period of enhanced scrutiny by the Federal Aviation Administration, ABX has passed all inspections with no findings, an unusual feat for a carrier of its size.

CUSTOMIZED
SUPPORT
PROGRAMS

Unique problems bring unique solutions.

You have a professional partner in CSI Digital, creating custom solutions to meet your specific service needs. CSI's technical support services allow your systems and your highly skilled staff to operate at their peak performance allowing you to do what you do best – your work.

CALL 1-800-624-0998 FOR THE OFFICE NEAREST YOU

TECHNICAL
SERVICES

CSI DIGITAL

Design Firm
Hornall Anderson Design Works, Inc.

Art Director
John Hornall

Designers
**David Bates, Margaret Long,
John Anicker**

Client
CSI Digital

Paper/Printing
Cougar Opaque, Heath Printers

*The client needed a capabilities brochure
that explained the different technical
services of the hardware/software
installation. This brochure started as a
multipurpose brochure that was integrated
into one piece. The client wanted their
technical department to have its own
look, while building on the piece's overall
corporate look.*

not just exhibits

Design Firm **Tanagram**
Art Director **Eric Wagner**
Designer/Illustrator **Eric Wagner, David Kaplan, Erik DeBat**
Copywriter **Lisa Brenner**
Client **MG Design**
Tools **Adobe Photoshop, Macromedia FreeHand, Strata, QuarkXPress**
Paper/Printing **Howard Antique Parchment, Productolith/Consolidated Printing**

This brochure illustrates the uniquely expansive range of services that MG
Design, an exhibit design company, offers to its clients. The piece is digitally illustrated
and the client's corporate colors were substituted for process colors on press.

Design Firm
Communication-Design Gabriele Maerz
All Design
Gabriele Maerz
Copywriter
Gabriele Maerz
Client
Elke Scheller
Tools
Nikon F5, Macintosh
Paper/Printing
Fedrigoni Symbol, one-color printing

This brochure was designed for a public dance school that offers courses to amateurs in different types of dance. All teachers are introduced, and all offered classes are described by level, subject, and time frame. The brochure is distributed free in schools, shops, and public institutions.

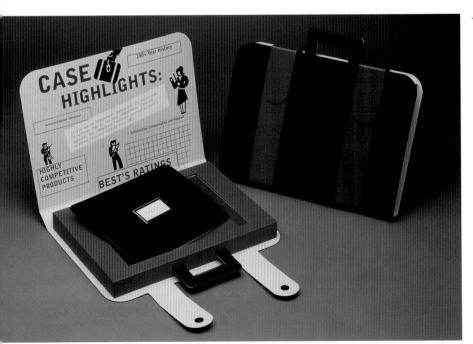

Design Firm **Sayles Graphic Design**
Art Director **John Sayles**
Designers **John Sayles, Jennifer Elliott**
Illustrator **John Sayles**
Copywriter **Jack Jordison**
Client **IMT Insurance**
Paper/Printing **Curtis Tuscan Terra, Offset and screenprinting**

Designed as part of a new agent-recruitment program for an insurance company, the project is actually a briefcase constructed of corrugated cardboard. The client's logo appears in varnish on the face of the briefcase. Inside the briefcase, a fitted tray holds a brochure that outlines "The Case for IMT." The brochure cover is a single sheet of black embossed leatherette, scored to hold brochure pages inside and bound with a metal fastener. A total of 150 pieces were produced.

Design Firm
Siebert Design Associates

Art Director/Designer
Lori Siebert

Illustrators
Juliette Borda, Lon Siebert, Lisa Ballard

Copywriters
Joe Lewis II, Joe Lewis III

Client
Contemporary Arts Center

Printing
Westerman Printing

*Cincinnati's Contemporary Arts Center
sponsors an outreach program in which a
visiting artist goes to inner-city schools and
gives a presentation. The children are given
this book that is so special in its design
they wouldn't dream of throwing it away.*

Design Firm **Design Ranch**
Art Director **Gary Gnode**
Designer **Kimberly Cooke**
Client **City of Iowa City Dept. of Planning and Community Development**
Paper **Mohawk Options**

In designing the look for the client's municipal mission statement for the next century, no edits were allowed. Size and wear weight were determined by the distribution method—the piece was to be included with all residential water bills.

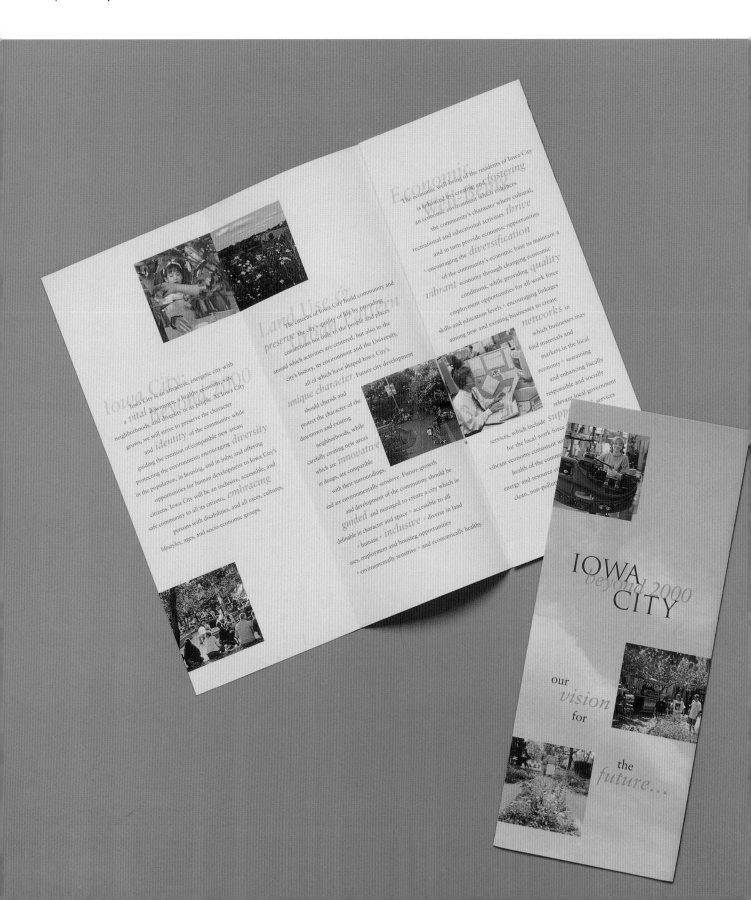

Design Firm
FJC and N

Art Director
Richard Oliver

Illustrator
Robert Neubecker

Copywriter
Richard Oliver

Client
San Mateo Light Rail

Done almost entirely with illustration in a single day's time, this piece served to encourage use of the commuter rail system.

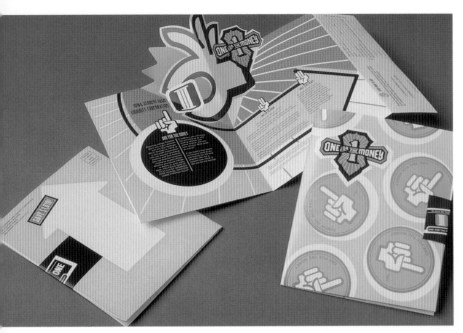

Design Firm
Sayles Graphic Design

Art Director
John Sayles

Designers
John Sayles, Jennifer Elliott

Illustrator
John Sayles

Copywriters
Greg Olson, Pam Kleese, Wendy Lyons

Client
Iowa Student Loan Liquidity Corporation

Paper/Printing
Springhill, Offset

Produced for the Iowa Student Loan Liquidity Corporation,
this colorful mailer includes a wraparound flap that holds the
brochure closed during mailing, but when opened, the piece
measures 16" x 23" and includes a die cut pop up.

Design Firm
Tim Noonan Design

Designer
Tim Noonan

Illustrator
Keith D. Skeen

Photography
Nancy Yuenkel

Client
Portico Funds

Tools
QuarkXPress, Adobe Photoshop

Printing
Four-color process plus two PMS

Intended for both employees and customers of Portico Funds, this
piece serves as a dual-purpose guide to all collateral materials. It helps
customers to learn more about Portico Funds and employees cross sell
the company's products.

PORTICO
FAMILY OF
FUNDS

literature
guide

PORTICO FUNDS

Design Firm **David Carter Design**
Art Directors **Lori B. Wilson, Sharon LeJeune**
Designers **Sharon LeJeune, Tracy Hock**
Photography **Philip Esparza**
Copywriter **Melissa Gatchel-North**
Client **Zen Floral Design Studio**
Paper/Printing **Mohawk Options/Jarvis Press**

Highlighting each of the client's services with beautifully photographed floral arrangements, the brochure captures the truly unique talents of the Zen floral designers. The piece was printed on uncoated paper to further enhance the natural and unassuming beauty of the client's floral designs.

Design Firm **Solo Grafika**
All Design **Yelena Suleyman**
Client **Sputnik Translation Services**
Tools **Power Macintosh, Adobe Photoshop,
Adobe Illustrator, QuarkXPress**
Paper/Printing **Hennah paper/Four-color process**

*Created using Photoshop, Illustrator, and Quark, the piece
needed to be catchy while maintaining a professional
appearance that was representative of the client's image in
the scientific and technical communities.*

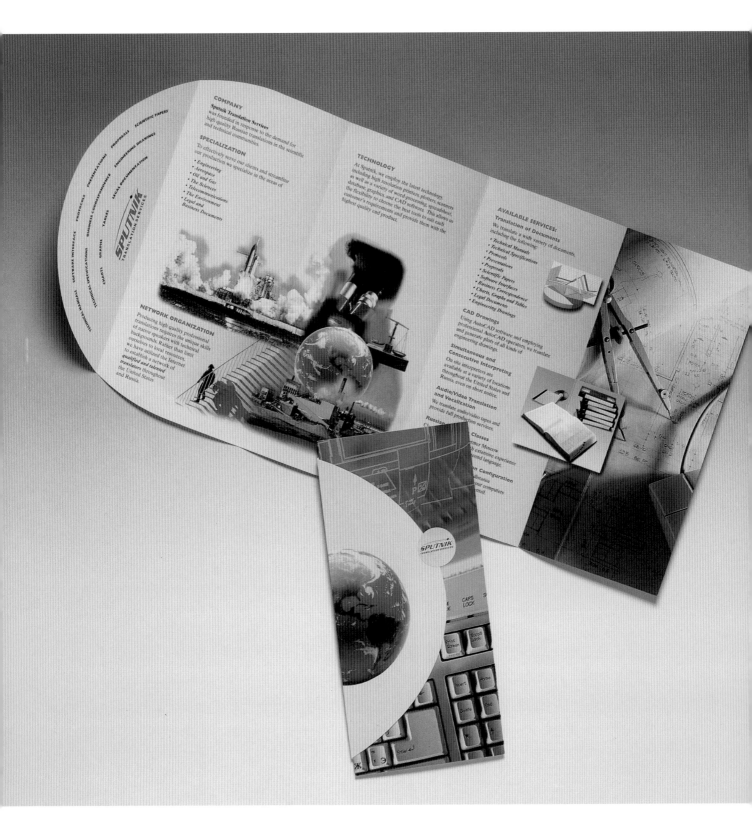

Design Firm
Hornall Anderson Design Works, Inc.
Art Director
Jack Anderson
Designers
Jack Anderson, Heidi Favour,
Mary Chin Hutchinson
Copywriter
Averill Curdy
Client
Quebecor Integrated Media
Paper/Printing
Cover, Champion 80 lb. Carnival black;
text, Centura 60 lb./Quebecor
Integrated Media, Graphic Impressions

The new design had to retain the corporate Q logo that is integral to the client's on-going identity program. The Q was restyled to resemble a very abstract circle, which starts out thick and migrates to a thinner line and some dots, with a line beneath. As a printer, the client relies on precision and timing; this was carried into the piece through a very technical look. The color palette remained relatively unchanged through each of the three name changes, helping to maintain a more consistent image.

AT QUEBECOR

...ated Media is assigned a team of experts in program management. These **hands-on** teams manage all aspects of your account, working closely with you to develop a customized program that fits your business and serves your customers. We've even placed team members at customer sites to increase **responsiveness** and enhance communication. To ensure continuity and the level of service you receive, ...members are cross-trained. And each team is **strategically** located within a focused manu...ng environment that is structured around ... clients with similar media delivery needs.

Design Firm **Widmeyer Design**
Art Director **Ken Widmeyer/Dale Hart**
Designer **Dale Hart**
Illustrator **Tony Secolo**
Copywriter **Washington Natural Gas**
Client **Washington Natural Gas**
Tools **Power Macintosh, Adobe Photoshop, Adobe PageMaker**
Paper/Printing **Evergreen/Two-color offset**

The brochure, "Saving By Degrees: No-Cost and Low-Cost Ways to Save Energy and Money," was designed as a handy guide for natural gas customers to help them conserve energy and make informed energy decisions about their home. Designed to have the look and feel of an owner's manual, the brochure outlines ways to caulk, insulate, and upgrade gas equipment and the relative cost savings associated with each.

SAVING BY DEGREES

NO COST and LOW COST WAYS TO SAVE ENERGY and MONEY

CONTENTS

Hot Water Usage page 8
Low-Flow Shower Head page 15
Insulating Walls page 24
Insulating Furnace Ducts page 25
Thermostat Setback page 6
Programmable Thermostat page 10
Weather-Stripping page 13
Caulking & Weather-Stripping page 11
Window Upgrade page 26
Water Heater Thermostat page 7
Water Heater Tank Wrap page 14
Water Heater Upgrade page 17
Furnace Maintenance page 15
Furnace Upgrade page 19

Design Firm
Sibley/Peteet Design
Art Director/Designer
David Beck
Client
The Image Bank

The Image Bank is a library of thousands of stock images. This brochure uses very diverse photos and concepts to show the range of offerings of the company. It allows the viewer to see the importance of the Image Bank.

Picture the POSSIBILITIES

IMAGE BANK

An
INTRODUCTION
to
STOCK
PHOTOGRAPHY,
ILLUSTRATION,
and
FILM

What else do I need to know?

Q. Why can't I have the images I select for unlimited usage for an unlimited period of time, just like the photography or film I contract for directly in assignment work?
A. When you hire a photographer, illustrator, or cinematographer, you pay for the actual costs of production and a mark up. Therefore, the artist has recouped the entire cost of the production. Because the cost of "leasing" a stock image or film series is comparatively low, the artist recovers his costs a little at a time.

Q. What's the difference between an original and a dupe? How can I tell them apart?
A. ORIGINALS ARE, AS THE NAME IMPLIES, ONE-OF-A-KIND IMAGES. NEITHER THE IMAGE BANK NOR THE ARTIST HAS COPIES. DUPES ARE FIRST GENERATION DUPLICATES OF ORIGINALS. THE IMAGE BANK USES THE BEST LABS IN THE WORLD TO ENSURE THAT OUR DUPES ARE OF THE HIGHEST QUALITY AND RESOLUTION POSSIBLE.

Q. Can I dupe an image and keep the dupe?
A. MAKING COPIES OF IMAGE BANK SLIDES OR FILM IS PROHIBITED BY LAW. ALL REPRODUCTION DUPES SENT TO YOU MUST BE RETURNED TO THE IMAGE BANK.

Q. Why do I have to call The Image Bank each time I reprint a job using one of your images?
A. When you "re-use" an image for an additional print run, advertisement, brochure, etc., it is, essentially, a new job for that image. The Image Bank must be contacted to negotiate a new contract.

Q. Can I manipulate Image Bank images?
A. Yes, as long as your manipulations are not derogatory or pornographic in nature. But the copyright of the image remains with the original Image Bank artist.

Q. How do I set up an account with The Image Bank?
A. Call The Image Bank nearest you and establish credit in your company's name. Once an account has been set up, we can deliver images to you without delay.

Q. Once I've selected images, how do I get them?
A. If you're not already in our office, call us and let us know what images you want to see. We will either courier them to you or send them via overnight delivery, depending on how close you are to our office.

Q. How long can I keep them?
A. We typically ask our customers to return any unused images within 14 working days. But if you need more time, let us know. Once you lease an image, we generally allow two months for all production to be completed. If you run over schedule, we can arrange for you to keep the image longer.

Q. How do I return images?
A. You can use any reputable courier service or overnight delivery service that provides both you and us with a receipt indicating proof of delivery.

Design Firm **Sibley/Peteet Design**
Art Director/Designer **Art Garcia**
Copywriter **Max Wright**
Client **American Physician Partners**
Paper/Printing **Centura gloss,
Glama Natural/ColorMark**

*American Physician Partners is a physicians' management
group specializing in radiology. This capabilities brochure
captures the essence of what they work with everyday—
black and silver duotones were printed in negative form on
translucent fly sheets.*

American Physician Partners, Inc.

In
day's
petitive
care field,
al to position
or success. As a
c Physician Practice
Management y (PPM), founded and
controlled by radiologists, American Physician
Partners, Inc. (APPI) understands your issues and
provides you with the resources and autonomy necessary
prosper in a rapidly changing marketplace. With extens
experience in radiology and business/operational managem
we offer you the competitive edge required to meet
challenges of today and tomorrow. And we bac
knowledge with capital, technology and m
ment expertise tailored to your
practice needs. The results?
competitive advantage.
to care for your
healthy bot
an i

Design Firm
Rickabaugh Graphics
Art Director/Designer
Mark Krumel
Illustrator
Michael Linley
Copywriter
Paula Jurenho
Client
Huntington Investment Group
Tools
Adobe Illustrator, Macromedia FreeHand

This guide informs the recipient of what products are available for retirement investing. The guide includes a moveable wheel that shows the readers' current financial situation and where they can be at time of retirement, depending on the investment options chosen.

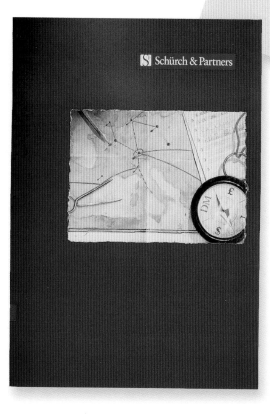

Design Firm **Tangram Strategic Design**
Art Director/Creative Director **Enrico Sempi**
Designers **Enrico Sempi, Antonella Trevisan**
Illustrator **Guido Pigni**
Copywriter **Consulenti Associati**
Client **Schurch & Partners**
Tools **Power Macintosh**
Paper/Printing **Zanders: Inconorex Special Matt 150 gsm/Offset**

*The Schurch and partners financial brochure contains lyrical
illustrations which show the project method, the competition, the
external forces at work, and an understanding of the market.*

Design Firm
Hornall Anderson Design Works, Inc.
Art Director
John Hornall, Lisa Cerveny
Designers
**John Hornall, Lisa Cerveny,
Heidi Favour, Taro Sakita**
Copywriter
Elaine Floyd
Client
Airborne Express
Paper/Printing
**Mohawk Options, French Butcher;
George Rice and Sons**

*The client's 1996 annual report was
designed to be quieter than the previous
one. There are three main photographic
segments featured throughout the report:
distribution, solutions, and business. The
cover was made using silver metallic ink on
butcher paper.*

Design Firm
Sibley/Peteet Design
Art Director/Designer
David Beck
Client
The Image Bank

This brochure was developed to
introduce designers and art directors to
stock photography, illustration, and
film. It takes the designer by the hand
and shows the diverse stock images
offered by the Image Bank.

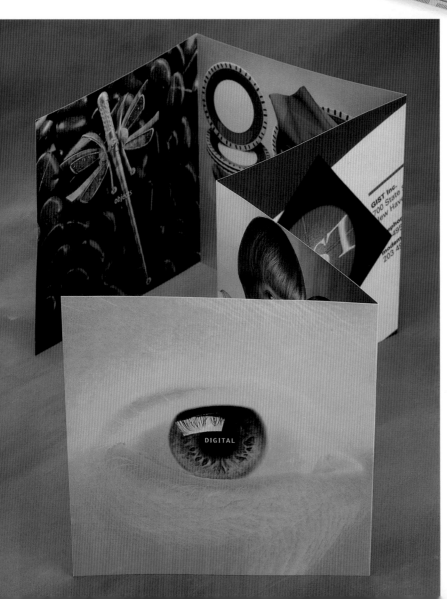

Design Firm **Reiser and Reiser**
Art Director **Tino Reiser**
Designer **Seth Mularz**
Copywriter **Margot Bradley**
Client **E3 Magazine/Freedom Communications**
Tools **Adobe Photoshop, Macromedia FreeHand**
Paper **Chromekote 80 lb.**

*This media kit introducing a new electronics publication in Latin America
utilizes existing product photography and original illustrations.*

Design Firm **John Gambell Graphic Design LLC**
Art Director **John Gambell**
Designer **Charles Routhier**
Photography **Tim Nighswander**
Copywriter **Lupi Robinson**
Client **Gist, Inc.**
Tools **Leaf digital camera, QuarkXPress**
Paper **Reflections 85 lb. cover**

*This piece was designed to introduce the clients' new
digital photography capabilities. Accordingly, the brochure
is image driven. The front panels comprise a rebus of
sorts, and the back is a gallery of the client's work—all
generated especially for this project.*

Design Firm **Sibley/Peteet Design**
Art Director/Designer **Donna Aldridge**
Client **The Image Bank**
Tools **Adobe Photoshop**
Paper/Printing **Padgett Printing**

This small accordion-fold piece was developed to be like a set of postcards. The Image Bank wanted to show the consumer the various ways of using their vast selection of black and white photographs.

Design Firm **Melissa Passehl Design**
Art Director/Designer **Melissa Passehl**
Client **Leadership Connections**

The objective of this brochure was to present the client as unique facilitators. A unique trim size and materials were used for the piece to parallel the client's method of redefining traditional modes of communication.

Design Firm
Hornall Anderson Design Works, Inc.
Art Director
Jack Anderson
Designers
Jack Anderson, John Anicker, David Bates
Copywriter
Corbis Corporation
Client
Corbis Corporation

This roll-fold brochure was designed for
distribution as a direct-mail promotional
piece to potential collectors of fine-art
imagery. It was one of the first
pieces designed for the client's digital
archival service.

C O R B I S

M E D I A

Design Firm **Markers and Brushes Design Consultant**
Art Director **Francis Lim**
Designer **Dyan Chang**
Illustrator **Francis Lim**
Client **Singapore Broadcasting Authority**
Tools **Macromedia FreeHand, Adobe PageMaker**

A major challenge in creating this piece
was maintaining a cohesive look despite
the fact that the submissions for the
contents came from nine different sources.
Vibrant color panels, subdued graphics,
and interesting typography were used
to provide unity to the piece and give it
needed visual emphasis.

Design Firm
The Weller Institute

Art Director/Designer
Don Weller

Illustrator
James Christensen

Copywriter
Olsen

Client
Praxis

Tools
QuarkXPress

Printing
Paragon Press

Using existing paintings to illustrate various points, the client wanted to make the brochure highlight the abilities of Praxis, a company that helps improve internal corporate communication. The result was informative but whimsical.

Praxis lifts the burdens of responsible leaders.

 ake a close look at our first picture and laugh a little—or maybe cry. What leader hasn't felt like this poor creature? Forget the heavy hat and the mournful carrot. Check out the backpack and the briefcase! In spite of carrying a heavy burden, he—or she—stands ever ready to forge ahead on the road to corporate vitality.

Just like you, today's responsible leaders shoulder a tremendous load. They must ensure that tens, hundreds, even thousands of people are acting in ways that *significantly and sustainably* add value to *all* of the organization's stakeholders. What a balancing act! What an accomplishment if they can pull it off!

At Praxis, we understand the burdens—and satisfactions—that leaders carry. We know the problems you face every day because we've been there, in the trenches, working with leaders of more than 300 of the Fortune 500 companies for over twenty years.

How do we help lighten the load?

As management consultants and trainers of personal, interpersonal, and organizational skills, Praxis has created a full line of products and services that touch every aspect of an organization's development needs—and get bottom-line results.

Why? Because our materials and change strategies are designed to meet the needs of *real* people in *real*-life, *real*-time situations. They provide everything from totally tailored culture-change interventions to dynamic off-the-shelf training delivered by your in-house professionals or by certified Praxis representatives.

If you take a close look at Praxis, you'll likely find what you're looking for—professionals with the necessary savvy to help you solve your problems and lift your burdens. At Praxis, we can help you meet your complex and often competing stakeholder demands, provide you with the right tools, or walk with you every step of the way on the road to lasting organizational vitality.

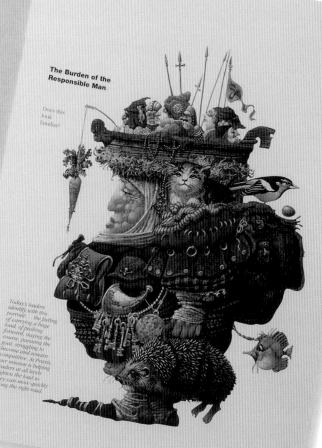

The Burden of the Responsible Man

Does this look familiar?

Today's leaders identify with this portrait . . . the feeling of carrying a huge load, of pushing forward, staying the course, pursuing the goal, struggling to become and remain competitive. At Praxis, our mission is helping leaders at all levels lighten the load so they can move quickly along the right road.

Design Firm **Widmeyer Design**
Art Directors **Ken Widmeyer, Dale Hart**
Designer **Dale Hart**
Illustrator **Tony Secolo**
Photography **Donna Day**
Copywriter **Ken Widmeyer**
Client **Centris**
Tools **Power Macintosh, Adobe Photoshop, Macromedia FreeHand**
Paper/Printing **Cross Point, Warren Lustro Dull/Four-color process**

Centris, a luxury executive suite located in a Seattle-area office tower, needed a brochure that focuses on typical problems experienced by small business startups, and shows how Centris can provide state-of-the-art solutions to the business needs of these customers. Updatable inserts in the back pocket of the brochure outline rental prices, features, and benefits, allowing the same brochure to be used for future office locations.

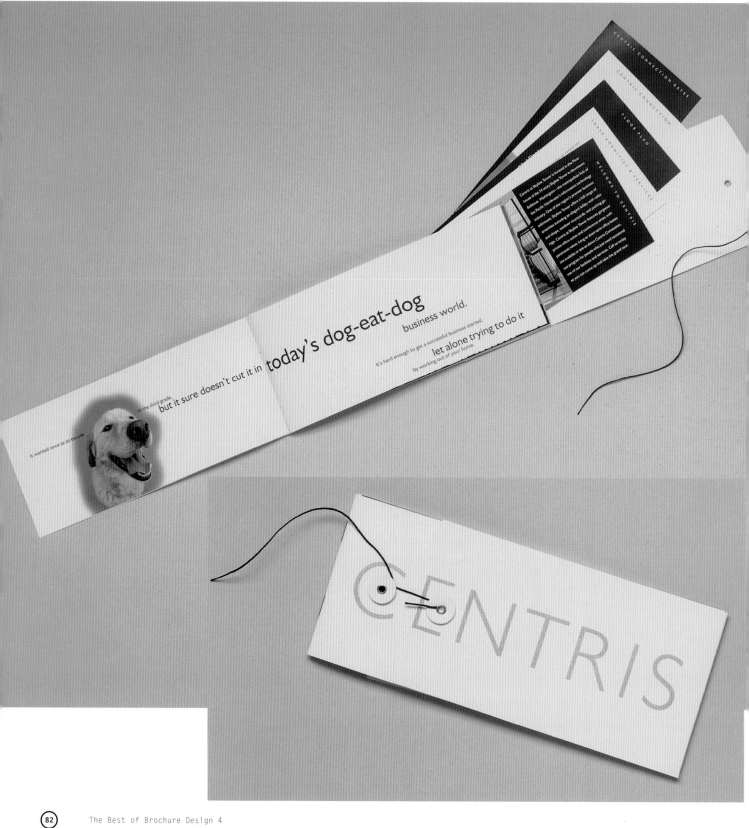

Design Firm
Sibley/Peteet Design

Art Director/Designer
Donna Aldridge

Illustrator
Phillipe Lardy

Copywriter
Vinnie Chieco

Client
Careington International

Paper/Printing
Strobe Paper/Padgett Printing

American Dental recently changed their name to Careington International, and wanted to introduce the new name and create a new identity for their company. To appear contemporary, forward thinking, and established, the designer used colorful, whimsical illustrations to give an uplifting style.

Photogrammetry

3DI's photogrammetry department, which launched the company's operations in 1974, is managed by a certified photogrammetrist. The department's staff uses leading-edge technology and equipment supported by expert skill and dedication to assure client satisfaction. Through the use of analytical stereo plotters, soft copy plotters, point transfer devices, and an array of mapping and engineering software, 3DI is able to provide the highest degree of accuracy in all of its services.

Through its interrelated technologies, 3DI has mapped a path of diversification to all aspects of the ever-changing photogrammetric industry. Today's business environment demands services from traditional aerial photography to the manipulation of panchromatic and multispectral satellite imagery for photogrammetric means. 3DI is meeting these challenges through the most industry-current methods.

■ **Airborne photography**
Wild RC 30 camera producing black and white, color, infra-red photography, enlargements, reductions, mosaics

■ **Traditional planimetric and topographic mapping for:**
transportation
utilities
engineering

■ **Color and black and white digital ortho photography for:**
backdrop in a GIS (rectified imagery)
as-built surveys
wetland delineation & identification
environmental impact studies
image view planimetric maps
vectorization tools

■ **Panchromatic and multispectral ortho satellite imagery for:**
backdrop in a GIS
land use classification
wetland delineation
environmental impact studies
vectorization tools

■ **Digital elevation modeling, cross-sections, and volumetric surveys**

■ **Imagery products include:**
land use classification
vegetation delineation and monitoring
precision agriculture
remote sensing
large and small scale mapping
digital ortho photography

■ **Select clients:**
Baltimore Gas & Electric
Corp of Engineers
Public Service Electric & Gas Company
Adams County, Pennsylvania

Imagery

Until the last decade, the high cost of satellite and airborne imagery acquisition for mapping and data collection limited the use of these methods to government and big industry. More recently, the development of faster, cheaper, and more "user-friendly" computers and software have made imagery data an affordable method for acquiring information. This improvement was underscored when, in 1996, the federal government elected to merge its mapping and imagery departments.

In the areas of satellite and airborne imagery acquisition, 3DI's experts can collect and classify multispectral, hyperspectral, panchromatic, and thermal imagery. Panchromatic satellite imagery is an excellent method for mapping large areas of land at a low cost, while producing accurate digital and hard-copy information. Multispectral imagery can be used to identify landuse and other terrain features. It also serves to map vegetation types and monitor surface changes. Hyperspectral imagery can be used in precision farming to detect pest and other stresses before they are viewable to the naked eye. In all three areas, 3DI's team of experts uses the most advanced equipment and technology in the market today to deliver products specifically designed to meet our clients' needs.

3DI
Geographic
Technologies

Design Firm
Whitney-Edwards Design
All Design
Charlene Whitney Edwards
Copywriter
Karin Counts
Client
3D Imaging, LLC
Tools
Adobe Photoshop, Adobe Illustrator, QuarkXPress
Paper/Printing
Vintage gloss 80 lb./Four-color process

With no photography budget, the graphic focus shifted to using maps and satellite images provided by the client. These resources proved effective in producing colorful layouts that were also used for the collage on the cover of the piece.

Design Firm **Department 058**
Art Director/Designer **Vibeke Nodskov**
Copywriter **Klaus Bircholdt**
Client **Leo Animal Health**
Printing **Offset with eleven spot colors**

The project involved converting a design manual into an eight-page brochure in order to make the information more appetizing and easy to use. Special appeal is brought to the piece through liberal use of color.

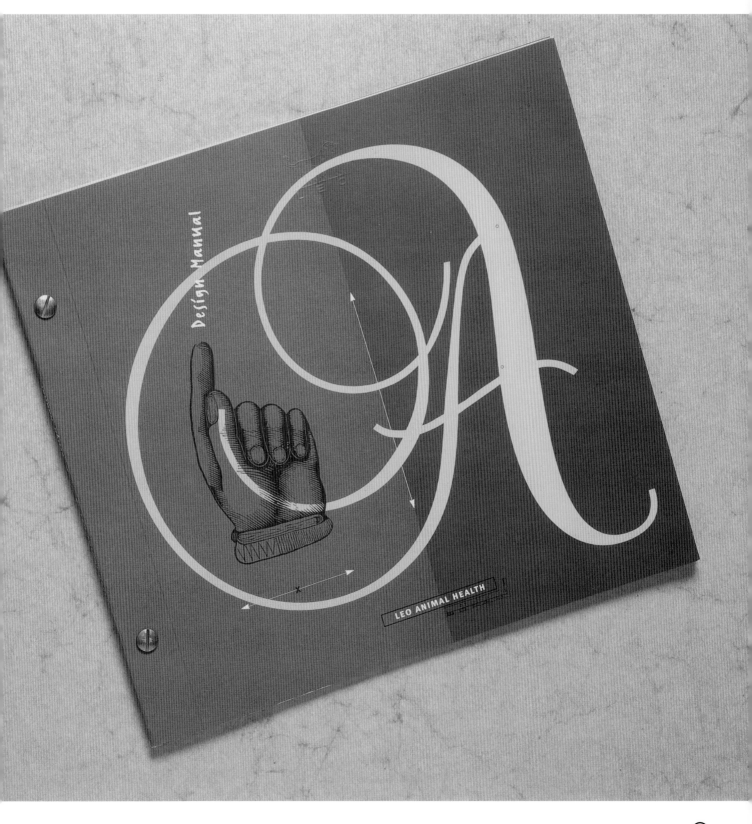

Design Firm **Sayles Graphic Design**
All Design **John Sayles**
Copywriter **Kristin Lennert**
Client **Cross America**
Paper/Printing **Curtis Tuscan Terracoat/Four-color offset**

In developing the new logo for Cross America, a monogram C was incorporated with a globe graphic and complementing typeface. The effect is striking, and the two-color corporate identity is also cost effective. The accompanying brochure features the company's philosophy and services printed on uncoated riblaid paper. The text pages alternate with glossy cast-coated pages featuring dramatic black-and-white photographs of images. The primary focus was to make the piece globally appealing, because of the nature of the client's business.

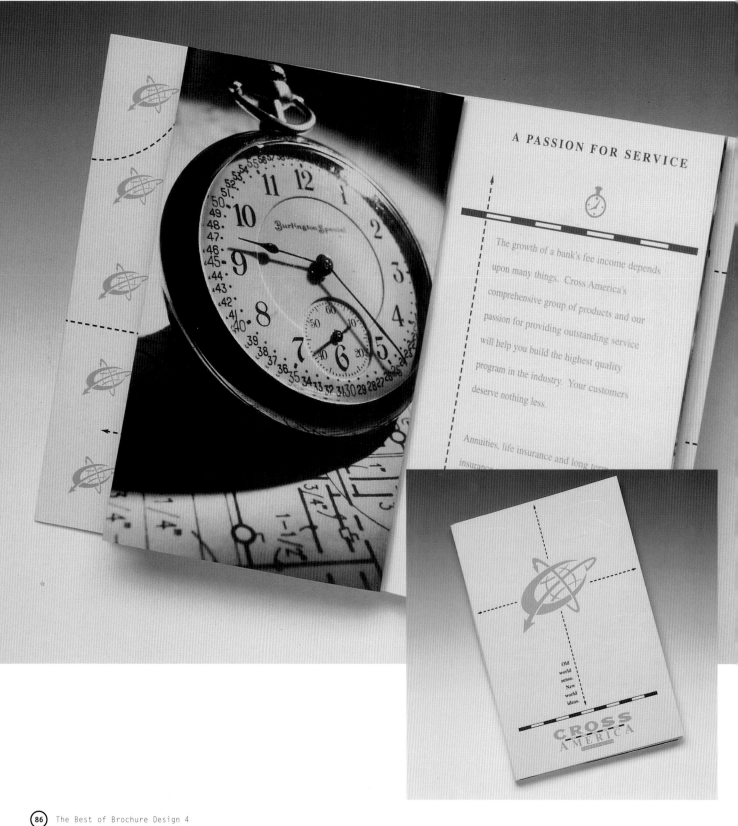

Design Firm **Cornoyer-Hedrick, Inc.**
All Design **Lanie Gotcher**
Copywriter **Mary Baldwin**
Client **Williams Gateway Airport**
Tools **QuarkXPress, Adobe Illustrator**
Paper **Quintessa 100 lb. dull; Folder/brochure/dividers:
Classic Crest 70 lb.**

*Designed to transform from a pocket folder to a proposal by trimming pieces
and wirebinding, this piece picks up airport runway elements and includes a
custom pocket folder with information sheets and a proposal book.*

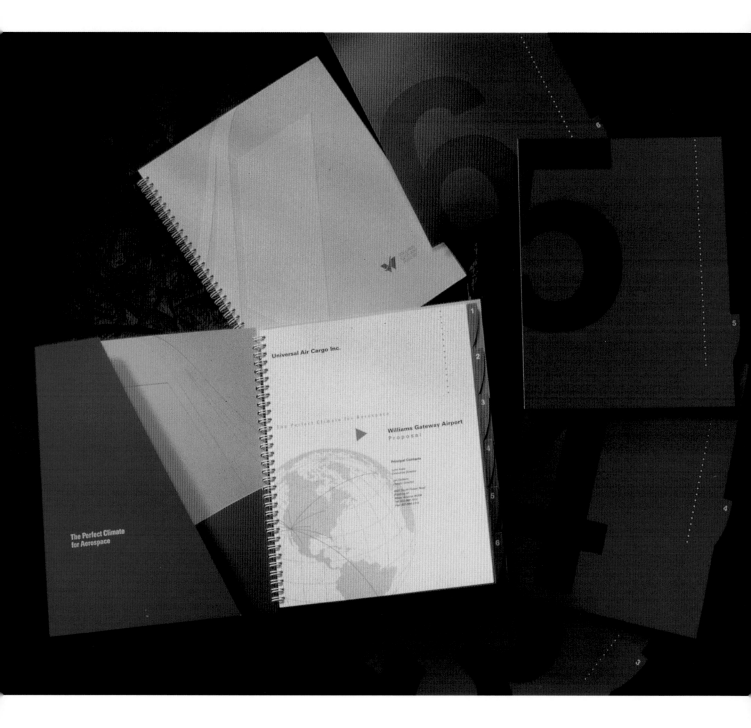

Design Firm **Hornall Anderson Design Works, Inc.**
Art Director **Jack Anderson**
Designers **Jack Anderson, Mary Hermes, David Bates, Mary Chin Hutchinson**
Illustrator **Yutaka Sasaki**
Copywriter **Jeff Fraga**
Client **NextLink Corporation**
Paper/Printing **Cover, Champion Benefit; text, Vicksburg Starwhite; Grossberg Tyler**

*The client, a full-service telecommunications firm, was changing its name from FiberLink to
NextLink to project a forward-thinking image—always planning for the next step in telecommu-
nications links. The piece creates an innovative identity through the use of custom lettering
and bold colors. The use of the slightly askew X further illustrates NextLink's role of "leaping-
into-the-future."*

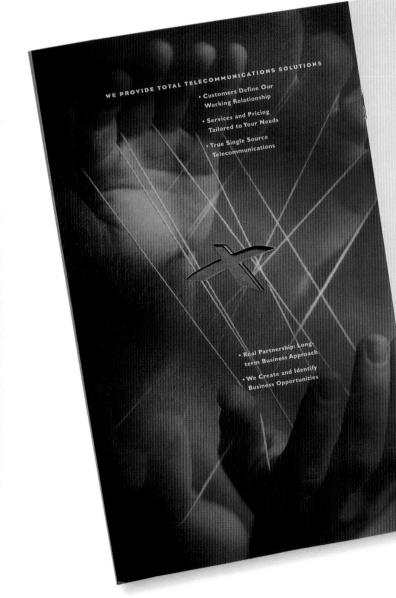

WE PROVIDE TOTAL TELECOMMUNICATIONS SOLUTIONS

• Customers Define Our
 Working Relationship

• Services and Pricing
 Tailored to Your Needs

• True Single Source
 Telecommunications

• Real Partnership: Long-
 term Business Approach

• We Create and Identify
 Business Opportunities

NEXTLINK is dedic
are created equal. Tha
require individual solutions. And that the right combination of
telecommunications products and services provides a **BUSINESS
ADVANTAGE**. You're probably not used to this approach. That's
understandable — traditional phone companies provide telephone
service. We provide **TELECOMMUNICATIONS SOLUTIONS**.

Our way of working is anything but traditional. In fact, we're out to
redefine the entire customer-telecommunications company relation-
ship. We start by working to understand not just your telecommunica-
tions needs, but also your **TOTAL BUSINESS**. Then we develop
a complete solution that can include local exchange service, long
distance service, voice messaging, and high-speed data networks. All
from a **SINGLE SOURCE**. And we work around your schedule.
Your requirements. Your definition of success. Refreshing, isn't it?

5

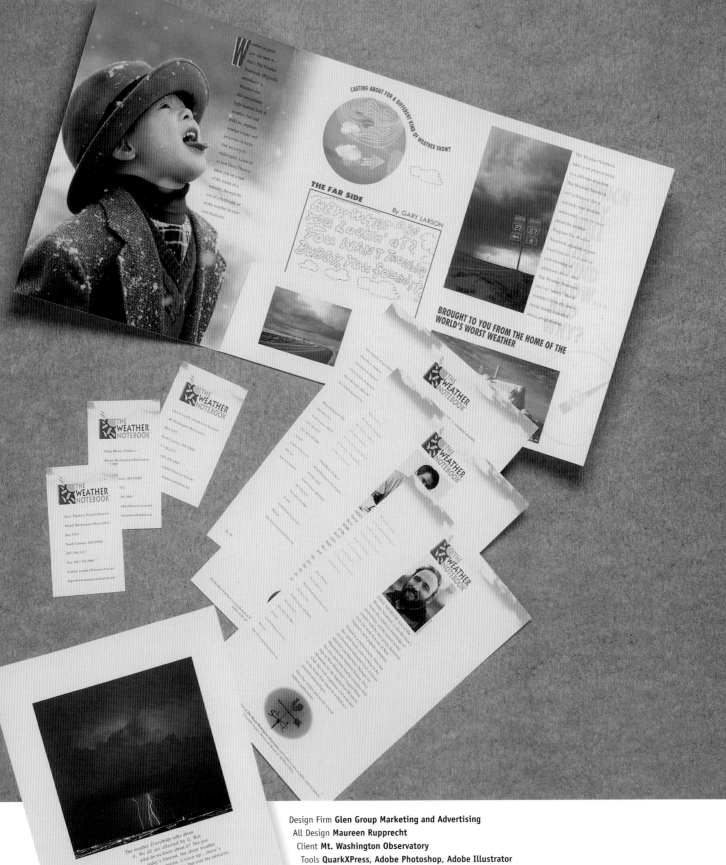

Design Firm **Glen Group Marketing and Advertising**
All Design **Maureen Rupprecht**
Client **Mt. Washington Observatory**
Tools **QuarkXPress, Adobe Photoshop, Adobe Illustrator**
Paper **Warren Flow 100 lb. gloss**

*This media package sent to primary public radio stations reflects the broad, lighthearted
scope of the free radio show being promoted. Response far exceeded expectations and the show
is now heard across the country. Additional funding from the National Science Foundation has
been provided for further work, including the production of a book.*

Design Firm **Communication Arts Company**
Art Director **Hilda Stauss Owen**
Designer **Anne-Marie Otvos**
Copywriter **David Adcock**
Client **Cook Douglass Farr Lemons, Ltd.**
Tools **Macintosh**
Paper/Printing **Patina matte, offset printing**

*The first in a series of brochures for the company, this brochure
is a corporate-image piece that provides an overview of services
offered by the client. Photo retouching and ghosting was done in
Photoshop while layout was done in Macromedia FreeHand.*

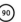

OSCAR GRUSS ◆ אוסקר גרוס
BROKERAGE SERVICES ✦ THE ISRAELI SECURITIES EXPERTS

"We are extremely proud of our long-standing relationships with clients. After all, we recognize that our reputation depends on our continuing ability to furnish superior trading services."

Oscar Gruss' expertise in Israeli public offerings is backed up by its extensive trading experience, ensuring continuous guidance for clients all along the line. Indeed, the firm has become a synonym for the trading of Israel-related stocks, displaying wisdom and insight in all markets and economic cycles ✦ The firm has a comprehensive range of clients in Israel, including financial institutions, individual clients and most of the country's banks. Foreign clients include U.S. institutions, entities and individuals regularly investing in Israeli securities ✦ As the major direct bridge between Israeli capital and the international financial markets, Oscar Gruss has become the premier broker for Israel's financial institutions investing in foreign markets. The latest Israeli-developed communications hardware and software technology, including high-speed voice, fax and data circuit connections, keep the Tel Aviv office on-line at all hours to the firm's New York headquarters, as well as to financial markets around the globe. Trading at Oscar Gruss is based on an efficient and expert "back office": proven specialists whose understanding of the market is equalled by the respect they hold for the interests of their clients.

"We provide a gateway for investors, handling much of the business for Israeli stocks on Wall Street, as well as serving foreign investors who are attracted to the Tel Aviv Exchange."

OSCAR GRUSS ◆ אוסקר גרוס
THE INVESTMENT SOURCE IN ISRAEL

Design Firm
Sadna Graphic Design
All Design
Eduardo Mitelman
Copywriter
The Wordshop
Client
Oscar Gruss
Tools
Macintosh

The client, an investment banking and securities firm, requested an attention-getting piece. Big illustrations and statements of the company's corporate philosophy appear on each page.

Design Firm
Raven Madd Design

Designer/Illustrator
Mark Curtis

Copywriter
Grant Chin

Client
Astra

Tools
Macromedia FreeHand

Design Firm
Hornall Anderson Design Works, Inc.
Art Director
Jack Anderson
Designers
Jack Anderson, Lisa Cerveny, Jana Wilson, Alan Florsheim, Mike Brugman
Copywriter
Frank Russell Company
Client
Frank Russell Company
Tools
QuarkXPress, Adoe Photoshop, Macromedia FreeHand
Paper/Printing
Mohawk Superfine/Williamson Printers

The client needed a new collection of capabilities brochures. This modular brochure package focuses on different Defined Contribution companies and helps to advance the client's growing list of services.

OFR Gruppo Riello

Design Firm **Tangram Strategic Design**
Art Director/Creative Director **Enrico Sempi**
Designers **Enrico Sempi, Antonella Trevisan**
Photographer **Roberto Zabban**
Copywriter **Meneghini & Associati**
Client **OFR Gruppo Riello**
Tools **Power Macintosh**
Paper/Printing **Zanders: Iconorex Special Matt
150 gsm/Offset**

The profile of the OFR Company—a prominent Italian central heating group—uses the sun to symbolize the first source of heat in life.

Design Firm **Sayles Graphic Design**
Art Director **John Sayles**
Designers **John Sayles, Jennifer Elliott**
Illustrator **John Sayles**
Copywriter **Jack Jordison**
Client **Greater Des Moines Chamber
of Commerce**
Paper/Printing **Curtis Tuscan Terra and
manila tag, Screenprinting and offset**

*Designed to promote Des Moines' warehouse
and distribution potential, the brochure has
a corrugated cardboard cover that is bound
with bolts and wing nuts. A die-cut arrow in
the corrugated board surrounds type that
tells the recipient "It's Your Move," while
reinforcing the industrial warehouse look of
the mailing. Inside, grainy photographs and
original illustrations are reproduced on
manila tagboard. Each spread features a
colorful label with a different warehousing
message—from "This Side Up" to "Made in
the USA."*

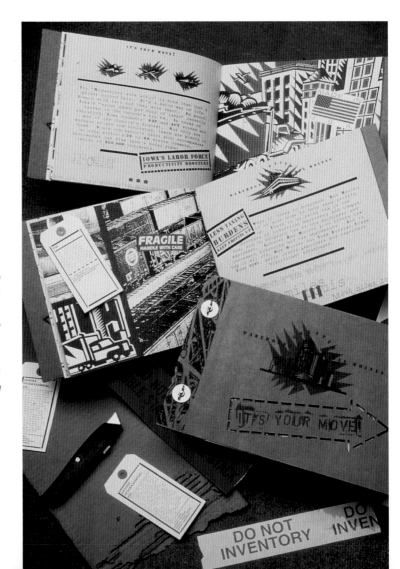

Design Firm
Mortensen Design

Art Director/Designer
Gordon Mortensen

Illustrator
John Craig

Client
Informix Software, Inc.

Tools
QuarkXPress, Adobe Photoshop

Illustrations played a large part in this brochure by helping direct the reader into the brochure and arouse interest in the brochure's primary message.

INFORMIX
DataBlade
TECHNOLOGY

Informix

▶

Design Firm
Palmquist and Palmquist

Art Director/Designer
Kurt Palmquist, Denise Palmquist

Photography
Will Brewster, Rob Outlaw, and Denver Bryan

Copywriter
Bison Engineering

Tools
Adobe PageMaker, Illustrator

Paper/Printing
Text, Productolith dull; folder, Curtis flannel/Four-color process

The goal was to create a concept for an environmental engineering firm that bridged the gap between industry and the environment and show how the two can co-exist and thrive.

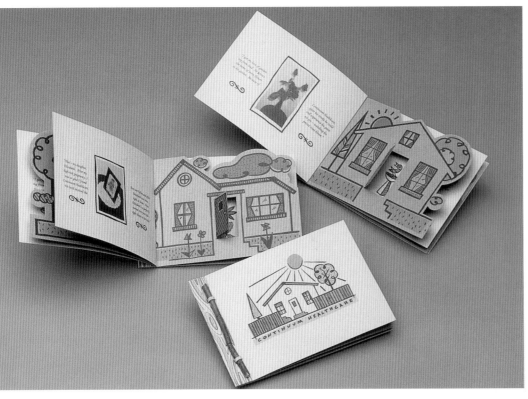

◀

Design Firm
Sayles Graphic Design

All Design
John Sayles

Copywriter
Wendy Lyons

Client
Continuum Healthcare

Paper/Printing
Curtis Tuscan Terra/Four-color offset

All Design **Carol Dominic, James Ison**
Copywriter **Lamplight Colour, Ltd.**
Client **Lamplight Colour, Ltd.**
Tools **QuarkXPress**
Paper/Printing **Cover Replica 190 g, text:**
CPP 160 g/Xeikon DCP-1 digital printing press

The piece's purpose was to feature the latest
advances in digital printing technology. To achieve
this, a contrast between past and present was used:
the stained-glass window represents a handcrafted
relic from the past, while the technology used to print
the image represents the latest in digital printing.
The stained-glass window's vibrant colors made it the
perfect subject matter. The images were shot over a
four-second period using natural light.

WINDOWS

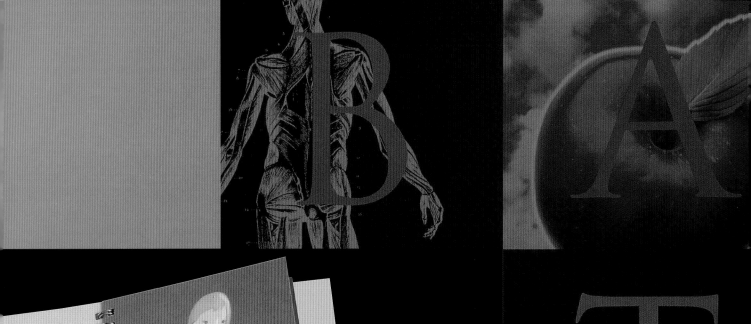

B

A

dent care
account

ad&d insurance

CREATE THE PERFECT MATCH

T

Y

R

VIEWBOO

new
Academy. Reme
language and reading se
provided by Lancaster L
Intermediate, Unit 13 to eligh
the Kindergarten and Elementa
Guidance and psychologic
are als

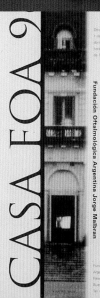

CASA FOA 9

Desde el martes
1 de octubre al
domingo 1 de diciembre.
horario: martes a domingo
de 11 a 20 horas

Fundación Oftalmológica Argentina Jorge Malbrán

Fundación Oftalmológica
Argentina Jorge Malbrán
Paraná 15 Piso 9 (1014)
Buenos Aires - Argentina
Tel. 812 - 1888

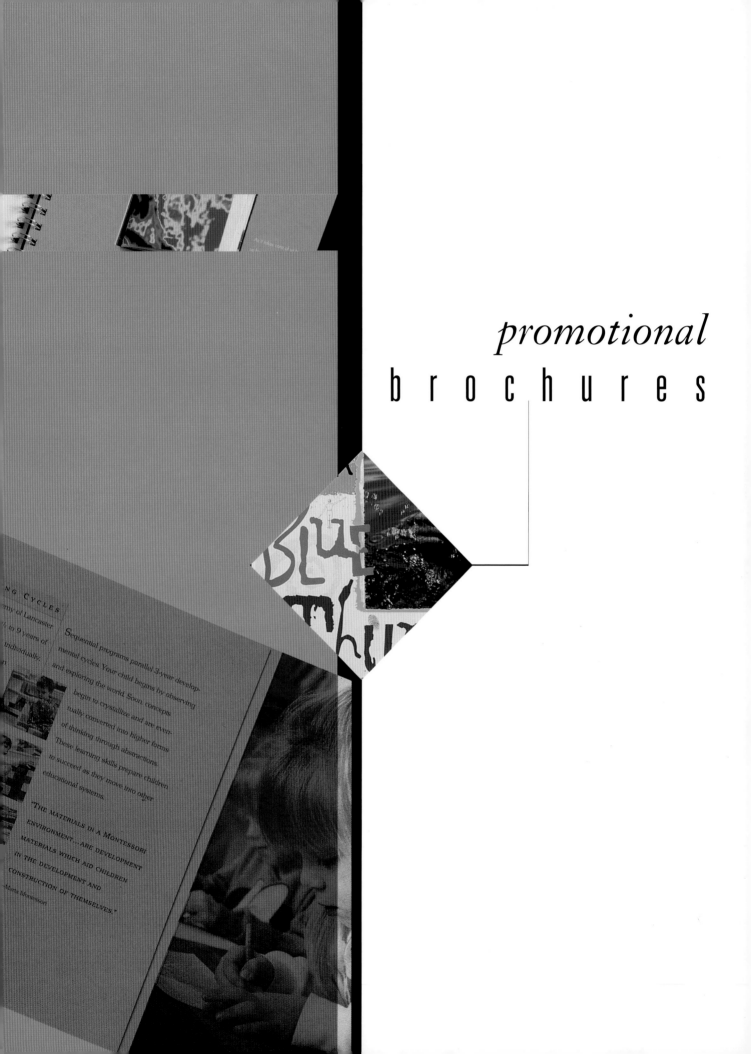

promotional
b r o c h u r e s

Design Firm
Letter Design

Art Directors
Paul Shaw, Garrett Boge

Designer **Paul Shaw**

Copywriter **James Mosley**

Client **Letter Perfect**

Tools **Macintosh IIci**

Paper/Printing **Mohawk
Superfine, Studley Press**

*This essay was commissioned and
designed to promote three new
historically-inspired typefaces.
The look of the essay is meant to
reflect the late Renaissance while
remaining contemporary.*

THE
BAROQUE
INSCRIPTIONAL
LETTER
IN
ROME

JAMES MOSLEY

Design Firm **Metalli Lindberg Advertising**
Creative Director **Lionello Borean**
Art Director **Stefano Dal Tin**
Copywriter **Corrado Casteuri**
Client **Cappamobili SRL**
Tools **Adobe Illustrator, Adobe Photoshop**

The piece concentrates on presenting the
unique products offered by the client.
From the function and meaning of the
door for furniture, to its normal move-
ment, concepts that outline the advan-
tages of a relationship with Cappamobili
are used throughout the brochure.

Design Firm **Lee Reedy Creative**
Art Director **Lee Reedy**
Designers **Helen Young, Lee Reedy**
Copywriter **Carol Parsons**
Client **American Waterworks Association**
Tools **QuarkXPress**

*This kit promotes the protection of drinking
water and is packaged in a chipboard cover
with numerous pieces inside.*

Design Firm **J. Graham Hanson**
Designers **J. Graham Hanson,
Dani Piderman**
Copywriter **Leslie Adler**
Client **American Institute of
Graphic Arts, New York**
Tools **Adobe Photoshop,
Adobe Illustrator, QuarkXPress**
Paper/Printing **Appleton Utopia/
Four-color process plus one PMS**

*An image was donated and downloaded
from Photodisk and manipulated in
Photoshop to create the clock/calendar
illustration. The actual calendar
information is purposely separate from
the illustration to enable the user to
effectively read all event information.*

Design Firm **Television Broadcasts Limited**
Art Director **Alice Yuen-wan Wong**
Principal Designer **Sai-ping Lam**
Designers **Isabella Wai-ping Chan, Kingslie Wai-king Chan**
Tools **Macintosh, Adobe Photoshop, Macromedia FreeHand**
Paper/Printing **Artboard, matte art paper; offset printing**

The brochure used embossing and special color-printing effects to emphasize the importance and international standing of the Oscar awards.

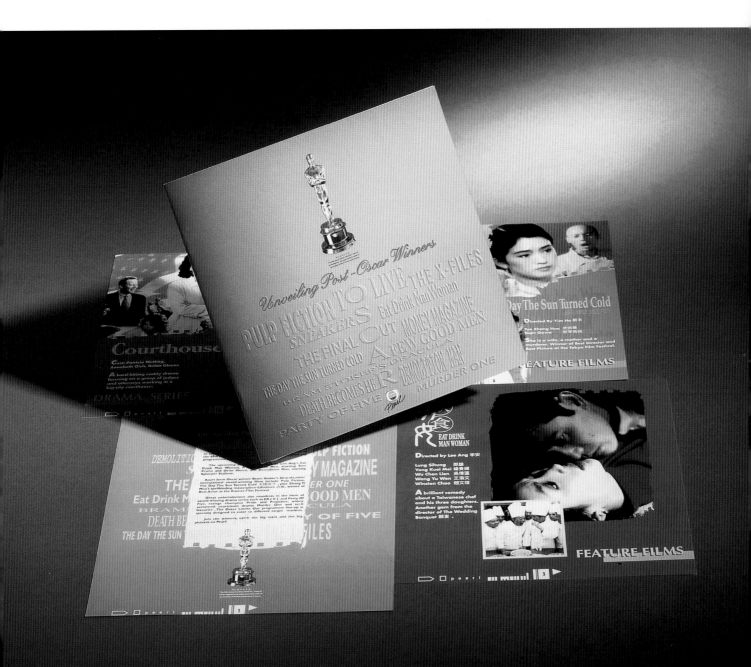

Design Firm **MartinRoss Design**
Designers **Martin Skoro, Ross Rezac**
Copywriter **Patricia McKernon**
Client **Pop Wagner and Stoney Lonesome**
Tools **QuarkXPress**
Paper/Printing **Coated paper/ Four-color process**

Using existing photos, the client wanted a brochure that would stand out from other promotions. A die-cut was used to make the distinction, and color, playful use of type, and trimmed photos were used to appeal to the people who booked shows.

Design Firm
Metalli Lindberg Advertising

Creative Director
Lionello Borean

Art Director
Stefano Dal Tin

Tools
**Adobe Illustrator,
Adobe Photoshop**

Paper
Fedrigoni Freelife

*Ecosphera, a new way of distributing
organic food products, is featured in this
retailer-focused brochure that includes
a non-profit philosophy that pays attention
to the market. Mailed in a brown paper
bag that is usually used for bread, the
nature of ecosphera is suggested, and the
piece acts as a pun about food and
consuming information.*

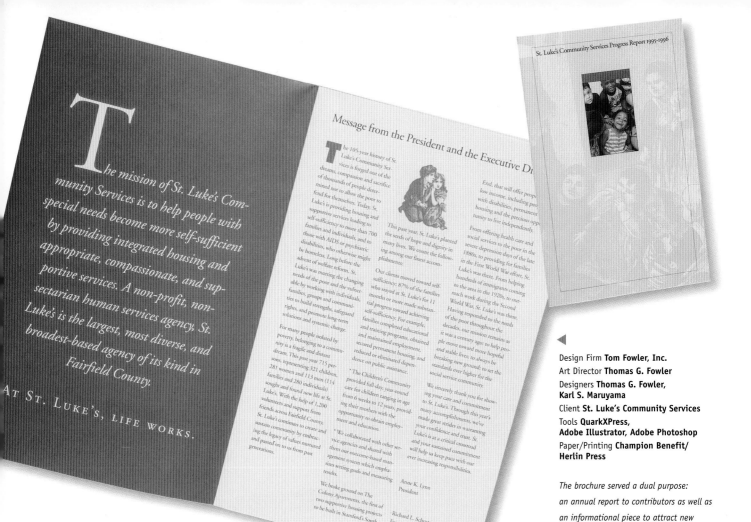

Design Firm **Tom Fowler, Inc.**
Art Director **Thomas G. Fowler**
Designers **Thomas G. Fowler,
Karl S. Maruyama**
Client **St. Luke's Community Services**
Tools **QuarkXPress,
Adobe Illustrator, Adobe Photoshop**
Paper/Printing **Champion Benefit/
Herlin Press**

*The brochure served a dual purpose:
an annual report to contributors as well as
an informational piece to attract new
supporters and volunteers.*

Design Firm
Dean Design/Marketing Group, Inc.
Art Director
Jane Dean
Designer
Gennifer Ball
Illustrator
Russ Cox
Copywriter
Jim Smith
Client
Montessori Academy of Lancaster
Tools
QuarkXPress, Adobe Illustrator
Paper/Printing
**Cross Point, Passport, Gypsum/
Two-color offset**

*The strategy of this two-color recruiting brochure is to reach out
to parents by communicating the Montessori education experience
through intimate photos of the children and the unifying ribbon
device. The school's location was to change so photos could not
portray the actual facility.*

NATURAL WONDER

It's a ritual older than civilization, one of nature's magnificent mysteries. Each springtime the salmon of the Atlantic respond to a silent calling, and start a grueling swim upstream, to return to the fresh waters of their birth.

And for just a few mad weeks each springtime, you can actually go beneath the surface of the Merrimack River to witness this amazing ritual firsthand. At the Amoskeag Fishways.

Fish stories. And a whole lot more.

The Amoskeag Fishways is a modern, computerized fish ladder that enables migrating salmon, shad and dozens of other kinds of fish–to make their way of Amoskeag Falls. But it's also a complete learning and visitor center, designed to give children and adults alike a new understanding and appreciation of the marvelous cycles of nature, and our place in it.

At the Amoskeag Fishways, you'll learn how the Atlantic salmon was instrumental in founding the city of Manchester. You'll learn about the local Native Americans who discovered the Falls, and why they named it "Amoskeag." You'll also see how the Amoskeag Falls helped power the city of Manchester into one of the premier manufacturing centers of its day.

herring–plus of freshwater to the head it's also a visitor center.

Fascinating. Fun. Free.

There's a lot more to Amoskeag Fishways than its one-of-a-kind window on the river. There are educational displays, and the automated "Village Along The Merrimack" – a quick guided tour of the development of Manchester over the past three centuries. There are audio-visual presentations, along with an overview of the nearby power station that still generates electricity, and a display of genuine Native American artifacts from Abnaki tribes that inhabited this area.

It's more than a great way to spend a spring afternoon. It's an adventure.

Amoskeag Fishways
Manchester, New Hampshire

Public Service of New Hampshire
The Northeast Utilities System

Amoskeag Fishways
Manchester, New Hampshire

Design Firm **Lynn Wood Design**
Art Director/Designer **Lynn Wood**
Illustrator **Bob Conge**
Copywriter **Jim Caron**
Client **Public Service of New Hampshire**
Tools **QuarkXPress**
Paper **Lithofelt Plus**

The brochure was designed to emphasize the fish, thus, the accordion fold. It was tricky to get the wave to match when folded.

wanted: FINANCIAL assistants

INVESTING IN OHIO'S CHILDREN

A Children's Defense Fund
Special Report
May 15, 1996

Design Firm
Firehouse 101 Art and Design
Art Director **Kirk Richard Smith**
Designer **Michelle L. Surratt**
Illustrator **David Butler**
Photographers **Photonica/Comstock**
Client **Children's Defense Fund/
Abigail House**
Copywriters **Susan Lewis, Linda Pitt**
Tools **QuarkXPress**
Paper/Printing **Millcraft Signature/
Baesman Printing**

*This brochure was created to advertise
the fourth annual benefit for the
Children's Defense Fund, which was
being sponsored by The Limited, Inc.
The design direction was to make the
piece loud and positive to represent the
spirit of kids.*

Design Firm
Kan and Lau Design Consultants
Art Director
Freeman Lau Siu Hong
Designer
Chau So Hing
Client
3.3.3 Group
Paper/Printing Booklet:
157 gm; Supporting board: 1800 gm
Tools
Adobe PageMaker

*Supporting board with die-cut note
and matte white foil were used to enhance
the piece.*

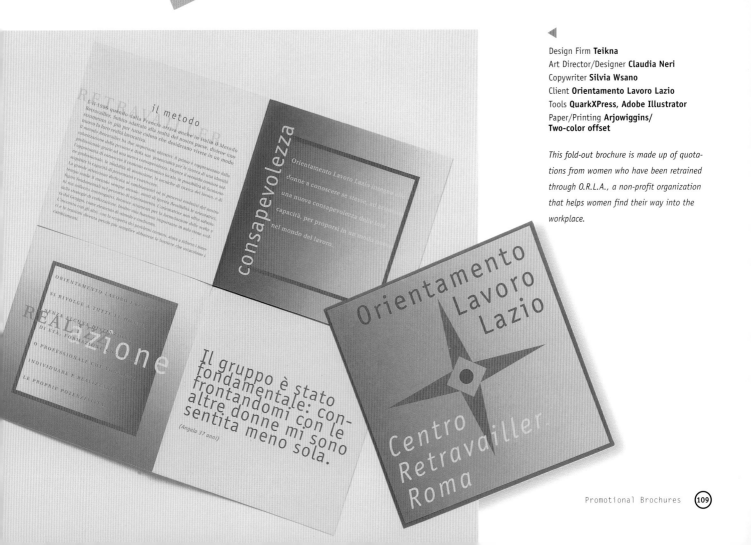

Design Firm **Teikna**
Art Director/Designer **Claudia Neri**
Copywriter **Silvia Wsano**
Client **Orientamento Lavoro Lazio**
Tools **QuarkXPress, Adobe Illustrator**
Paper/Printing **Arjowiggins/
Two-color offset**

*This fold-out brochure is made up of quota-
tions from women who have been retrained
through O.R.L.A., a non-profit organization
that helps women find their way into the
workplace.*

Design Firm **Rickabaugh Graphics**
Art Director **Eric Rickabaugh**
Designer/Illustrator **Rod Smith**
Copywriter **Diane Dixon**
Client **Mid-Ohio Food Bank**
Tools **Adobe PageMaker,
Adobe Illustrator, Adobe Photoshop**
Paper/Printing **Cougar Opaque/
Two-color offset**

*This annual report was created to focus
on the people who had donated food to
the Mid-Ohio Food Bank. A certain food
was used to graphically represent each
group of donors and when all the foods
were combined, a complete meal
appeared. The illustrations were created
in Illustrator and given a soft glow in
Photoshop.*

Design Firm
Kiku Obata and Company
Art Director/Designer
Joe Floresca
Illustrator
Maira Kalman
Copywriters
Sara Harrell, Maira Kalman
Client
Barnes and Noble
Printing
Watt-Peterson

*The project's objective was to show a
fun, unexpected side of a corporate book-
store while incorporating the necessary
financial information. The designer created
fictitious characters to take the reader on
a tour of an imaginary Barnes and Noble
bookstore through outlandish illustrations
and witty writing.*

Design Firm
Anderson-Thomas Design, Inc.

Art Director/Designer
Jade Novak

Photography
David Bailey

Client
Servant Group International

Tools
QuarkXPress, Adobe Photoshop

Paper/Printing **Cover, Simpson Quest;
text, Fortune matte/Four-color process**

*The task: change a shoebox full of photos and papers into an attractive
brochure. By combining professionally photographed backgrounds with
snapshots provided by the client, an air of nostalgia was created while
maintaining a credible look.*

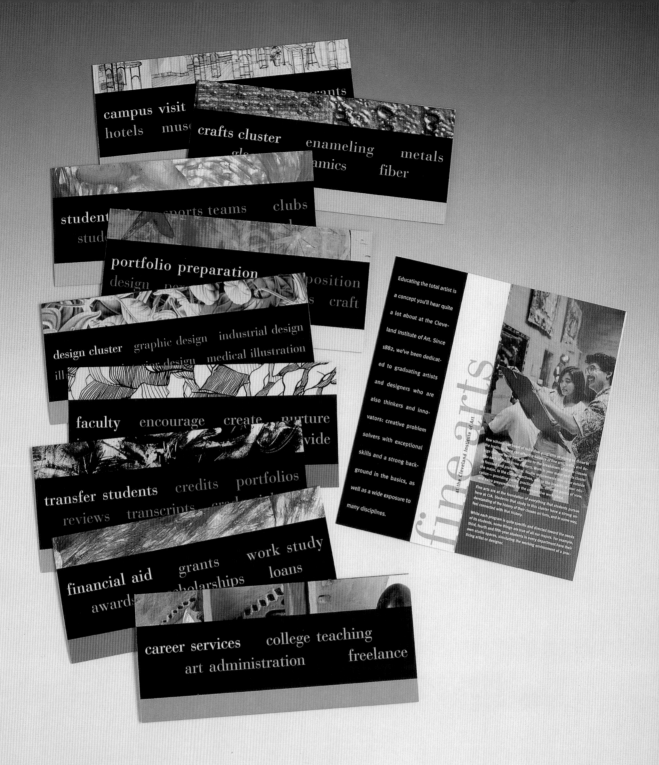

Design Firm **Nesnadny and Schwartz**
Art Director **Michelle Moehler**
Designers **Michelle Moehler, Melissa Petrollini**
Illustrator **Melissa Petrollini**
Copywriter **Cleveland Institute of Art**
Client **Cleveland Institute of Art**
Tools **QuarkXPress, Macromedia FreeHand, Adobe Photoshop, Adobe Illustrator**
Paper/Printing **Warren Lustro 80 lb. dull, Fortran printing**

This new series of brochures was created as a recruiting tool for the Cleveland Institute of Art. Intended for prospective students, they are mailed in a sequence designed for each recipient to communicate details about the college and its programs.

Design Firm
Emerson, Wajdowicz Studios
Art Director **Jurek Wajdowicz**
Designers **Lisa LaRochelle,
Jurek Wajdowicz**
Copywriters **Eugene Richards,
Daiv Konigsberg**
Client **Island Paper Mills,
Division of E. B. Eddy Forest Products, Ltd.**
Paper/Printing **Bravo/Offset**

*This brochure is the first in the Bravo Photo
Masters series, presenting a sampling of the
best photo journalism in the world. It was
created to intertwine and appropriately
merge photography, design, and typography
into one expressive and unique form.*

BRAVO RICHARDS

Blind Elder Counsel: "I am unmoved because he can't see me. Then he touches my face, and a connection is made." Eugene Richards/USA. Bravo Photo Masters Series, Issue 1 from Island Paper Mills.

Design Firm
Greteman Group
Designers
Sonia Greteman, James Strange
Illustrator
James Strange
Copywriter
Allison Sedlacek
Client
**Wichita Industries and Services
for the Blind**
Tools
Macromedia FreeHand
Paper/Printing
Cougar White/Offset printing

*This annual report transcends service as a
vehicle for financial accountability by focus-
ing on what it means to be blind. Bold
graphics and actual quotes walk readers
through the isolation, risk taking, and
challenges faced by people with low vision.
Die cuts illustrate their different perspec-
tive, while embossing conveys their greater
reliance on touch.*

See

See the world in a different way.

WICHITA INDUSTRIES AND SERVICES FOR THE BLIND, INC.
1995 ANNUAL REPORT

Taking risks requires courage and encouragement.

"It's easier because I have family,
but it's also hard emotionally
sometimes to do things on your
own. I want to know I can do it."

IF SOMEONE WILL KEEP ASKING HIM THESE SAME QUESTIONS OFTEN AND IN VARIOUS FORMS, YOU CAN BE SURE THAT IN THE END HE WILL KNOW ABOUT THEM AS ACCURATELY AS ANYBODY.

Plato, 5th Century B.C.

"WHAT IS DIFFERENT ABOUT
FLAHERTY'S APPROACH IS
THAT IT IS ABOUT SUSTAINING
CHANGES, BOTH INDIVIDUALLY
AND ORGANIZATIONALLY.
PRAGMATIC, RIGOROUS AND
COMPASSIONATE, FLAHERTY
WORKS WITHIN THE UNIQUENESS
THAT EACH PERSON REPRESENTS,
UNLEASHING THEIR PERSONAL
EFFECTIVENESS IN AMAZING,
BREAKTHROUGH WAYS."

—Sarita Chawla
Editor, Learning
Organizations

"THE GREATEST REWARD WILL
BE A PERSONAL CHANGE
THAT EXPANDS YOU IN A WAY
THAT YOU MIGHT NEVER HAVE
DREAMED OF. IT OPENED UP
A WHOLE NEW RANGE OF
POSSIBILITIES THAT I WOULD
NEVER HAVE COME TO WITHOUT
THE COACHING PROCESS OF
NEW VENTURES WEST."

—Ken Murphy
Co-founder,
Mecaleni Consulting
Former Comptroller,
Pacific Bell

COACHING: A Competence for All Times—Especially Now

Coaching has always existed in human communities. Whenever someone wished to pass along accumulated wisdom or practical know-how in a way that left the recipient competent and engaged in learning, coaching was present. This is as true today as it was in Plato's time. That's why coaching is a core competence for those engaged in developing learning organizations. In fact, in our world now, coaching can provide an essential powerful methodology for developing people so that they are both more competent and more fulfilled.

Our contemporary world is full of rapid change in which no one can predict which technologies, institutions or organizations will flourish, which will fade. Certainty is scarce. There is little time for theoretical discussions, yet people must quickly make choices, allocate resources, rapidly adapt and stay highly competent. Simultaneously these same people need a sense of purpose, of meaning — that what they're doing matters and fits with what's most important to them. It seems a daunting task to build competence and encourage fulfillment within this environment. Yet that's what coaches do. They're rigorous in their standards, yet flexible enough to suit individual people and unique circumstances.

Coaches build competence, foster personal fulfillment and open up possibilities by drawing upon the knowledge of what's unchanging about human life and taking into account that which is particular about our times. To be useful, of course, coaching must be eminently practical and be helpful in both the immediate and the long term. Coaching can only accomplish all this when it's practiced by people who are highly skilled, experienced, and models of what they represent. Our program, The Professional Coaching Course, produces such people.

NEW VENTURES WEST

PROFESSIONAL

COACHING COURSE

Design Firm
Clark Design

Art Director
Annemarie Clark

Designer
Dan Doherty

Copywriter
Stacy Flaherty

Client
New Ventures West

Tools
QuarkXPress, Adobe Photoshop

Paper/Printing
**Cover, Sundance 65 lb. maize,
text, Karma 100 lb. natural**

The brochure needed to be designed to accompany existing collateral materials. The client wanted the piece to visually represent the fact that the company's techniques are grounded in historical teaching. Present-day mentor/student images were used in combination with those of the past, along with the use of the Greek column to represent history, a strong foundation, and education.

Design Firm
Aerial
Art Director/Designer
Tracy Moon
Client
ODC Dance/San Francisco
Tools
**Adobe Photoshop, Live Picture,
QuarkXPress**

*This brochure is for a unique San Francisco
dance group that features unusual,
asymmetrical movement.*

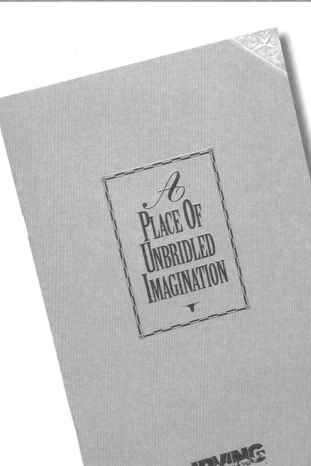

Design Firm **The Wyatt Group**
Art Director **Mark Wyatt**
Client **City of Irving, Texas**

*This piece uses Irving's roots as a
Texas city and plays to the expec-
tations of out-of-town business
travelers and meeting planners,
leveraging Irving's heritage as a
unique experience.*

Design Firm **Greteman Group**
Art Director **Sonia Greteman**
Designers **Sonia Greteman, Craig Tomson**
Client **The Chamber**
Tools **Macromedia FreeHand**
Paper/Printing
Classic Crest/Offset printing

This piece does double duty as an annual report and an interactive, capabilities brochure. Through its color choice, fun folds, straight-forward text, and relatively small size, the brochure positions the Chamber of Commerce as a progressive entity—one people would want to do business with.

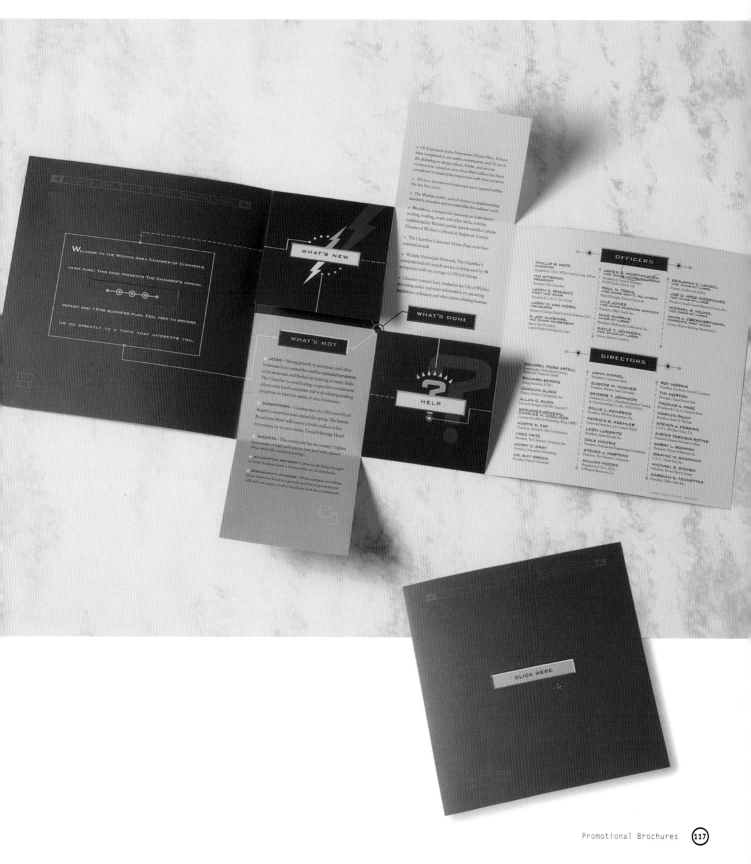

Design Firm **Greteman Group**
Art Director/Designer **Sonia Greteman**
Client **Petroleum, Inc.**
Tools **Macromedia FreeHand**
Paper/Printing
Warren Lustro dull/Offset printing

The innovative use of topographic charts, photography, and graphs turns this relatively low-budget piece into a powerhouse marketing tool. Dramatic, vibrant colors and evocative text create interest and a sense of story. Bold typography coupled with simple type creates a sense of scale and importance to the message.

6 The Jews Wailing Place, a Friday
The Western Wall of Herod's Temple, sometimes called "The Wailing Wall," is a sacred site for prayers and lamentation.

7 Jewish Types
By 1880, the total population of Jerusalem was 39,175 of which 25,000 were Jews.

8 Rabbi of Jerusalem
Reb Zusman Vasher was a pious man residing in Meah Shaarim where he maintained a monument shop. He was a community leader selected to act as an emissary for prayer money (halukkah).

Design Firm **Wood/Brod Design**
Art Director/Designer **Stan Brod**
Copywriter **Judith Schulzinger Lucas**
Client **Hebrew Union College—
Jewish Institute of Religion**
Paper/Printing
Speckletone/Gardner Graphics

*This brochure was designed to
commemorate the 3000 year anniver-
sary of the city of Jerusalem, Israel.
The vintage photos (1860–1905) are
from a collection that depicts the
earlier times and history of Jerusalem.
The photos with their sepia color and
natural-colored paper combine to
present a clearer picture of those
historic times.*

Design Firm
Greteman Group
Art Director
Sonia Greteman
Designers
Sonia Greteman, James Strange
Copywriter
Tami Bradley
Client
Kansas Health Foundation
Tools
Macromedia FreeHand
Paper/Printing
Cougar White/Offset printing

Along with the obligatory financial information, this annual report conveys a larger story—the changing nature of health care and the client's role in it. Readers are drawn in by the die-cut cover with its window and embossed words highlighting both problems and solutions. Bold sanserif and serif typefaces are juxtaposed and add scale while giving the message a sense of immediacy.

KANSAS HEALTH FOUNDATION

WHAT IS HEALTHY

1994 ANNUAL REPORT

37% 37% PERCENT OF CALORIES IN SCHOOL LUNCHES ARE FROM FAT (TARGET: 30%)

35% 35% OF ELEMENTARY SCHOOL CHILDREN DON'T EAT FRUIT.

60% 60% OF TEENS DON'T EAT FRUIT.

MORE THAN 20% OF CHILDREN IN THE UNITED STATES ARE OVERWEIGHT. **20%**

25% 25% OF SCHOOL-AGE KIDS DON'T EAT VEGETABLES.

50% 50% OF SCHOOL-AGE CHILDREN DON'T EXERCISE ENOUGH TO DEVELOP HEALTHY HEARTS AND LUNGS.

school lunch gets Lean

It's sitting down to a school lunch of fresh-baked breads, orange wedges, green vegetables and skim milk. It's fresh air, a fitness break and smiling, healthy faces. But more than that, it's instilling an appetite for health in young people.

The Kansas LEAN (Low-fat Eating for America Now) School Health Project fills elementary students' plates with healthy school lunches. Provides students with nutrition education and increases their level of physical activity. In short, it provides students a healthy start to their day and to the rest of their lives.

Through pilot programs in Salina and Dighton, the school health project proved its worth. In 1994, funding was expanded into six more school districts. A joint effort between the Kansas Department of Health and Environment and the Kansas Health Foundation, the project is a partnership among these organizations and the local communities.

It's an investment in the future health of our children and ourselves.

Design Firm
Melissa Passehl Design

Art Director
Melissa Passehl

Designers
Melissa Passehl,
Charlotte Lambrechts

Client
Girl Scouts of America

The objective of this annual report
was to show the full strength of
girl power in Girl Scouts. Fuchsia
was used as the symbolic color of
girl power while photojournalistic
photos featured the day and life of
a girl with girl power.

Design Firm
Medical Economics Publishing

Art Director/Designer
Wendy Wirsig

Copywriter
Allison Ziering

Client
***Contemporary Pediatrics* magazine**

Tools
Adobe Illustrator, QuarkXPress

Paper/Printing
Vintage Velvet 80 lb. cover

The objective in creating this combination media kit and brochure was to have a leave-behind sales piece for the client's advertising representatives. The client wanted a design that would catch the attention of prospective advertisers as well as tie in with the format of the magazine, which is geared toward children's health. A bright, colorful, and child-like format was used and clip art was used and modified in Illustrator.

PLEASE JOIN
CA ONE SERVICES
IN
SAN DIEGO

YACHTING
ON THE
STARS & STRIPES
AND
GOLF AT THE
AVIARA

CA ONE SERVICES • 438 MAIN STREET • BUFFALO, NY 14202

A SPECIAL INVITATION

WE WANT TO EXPRESS OUR APPRECIATION
TO OUR VALUED FRIENDS AND ASSOCIATES
WHILE YOU ATTEND THE ACI CONFERENCE
IN SAN DIEGO.

YOU ARE CORDIALLY INVITED TO JOIN CA ONE
SERVICES FOR GOLF ON THE COURSE OF THE
AVIARA GOLF CLUB, AND YACHTING WITH
DENNIS CONNOR ON THE STARS & STRIPES

PLEASE FAX BACK THE REPLY CARD BY
SEPTEMBER 30, 1996, SO WE CAN RESERVE
YOUR PLACE ON THE YACHT AND THE
COURSE. SEE YOU IN SAN DIEGO!

Design Firm
Robert Bailey Incorporated

Art Director/Designer
Connie Lightner

Client
CA One Services, Inc.

Tools
**Adobe Photoshop, Adobe Illustrator,
QuarkXPress**

Printing
Dynagraphics

*This invitation for a golf and yachting
event went to CA One's clients attending a
conference in San Diego. To keep costs
down, the invitation is two-color on an
economical house stock. The background
image is a portion from a navigation map
of San Diego Bay.*

CYRIX 1996 ANNUAL REPORT

Design Firm
Sullivan Perkins
All Design
Kelly Allen
Copywriter
Elizabeth Gluckman
Client
Cyrix
Paper/Printing
Fortune/WORX

*Cyrix, a computer chip company,
wanted to show new products and
advancements. The message was
carried through the piece by choosing
appropriate highway signage and
background.*

Design Firm
Aerial
Art Director/Designer
Tracy Moon
Client
Hotel Boheme/San Francisco
Tools
**Adobe Photoshop, Live Picture,
QuarkXPress**

*This brochure is for a small, North Beach
San Francisco hotel with a fifties,
Bohemian style and decor. All pattern,
imagery, and photography in the piece
draw directly from the hotel itself and the
Beat-era time period.*

Design Firm
Melissa Passehl Design

Art Director/Designer
Melissa Passehl

Illustrator
Melissa Passehl

Client
Berryessa Union School District

The objective of the "Success for All Learners in School and in Life" brochure was to present an overview of a new curriculum to teachers who instruct grades 1–8. The illustrations and bright colors remind the reviewer of the ultimate audience who benefits from the program.

SUCCESS
FOR ALL
LEARNERS
IN SCHOOL
& IN LIFE

Design Firm
Rapp Collins Communications
Art Director/Designer
Amy Usdin
Illustrator
Alex Bois
Copywriter
Brad Ray
Client
3M
Paper/Printing
**Neenah Environment/
Maximum Graphics**

The 3M Coping Kit was developed to help employees cope with a difficult corporate restructuring. The kit was distributed by counselors, occupational nurses, and HR managers. In contrast to the somewhat serious subject matter, the graphics and illustrations were bright, playful and inviting, to encourage use of the materials.

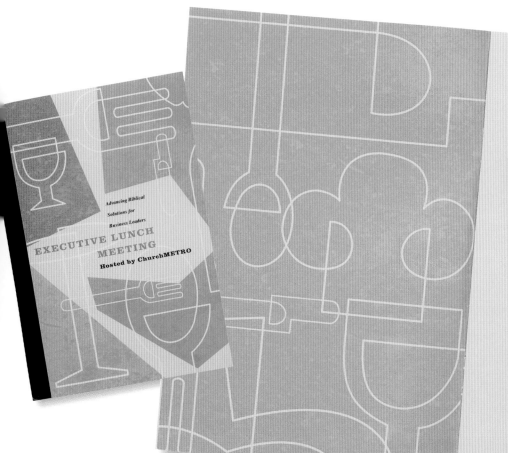

Design Firm **Design Center**
Art Director **John Reger**
Designer **John Erickson**
Copywriter **Church Metro**
Client **Church Metro**
Tools **Macintosh, Macromedia FreeHand**
Paper/Printing **Warren Lustro/Printcraft**

This brochure was mailed to executives and needed to be impressive enough to avoid being categorized as junk mail. It has fun graphics while conveying a serious message.

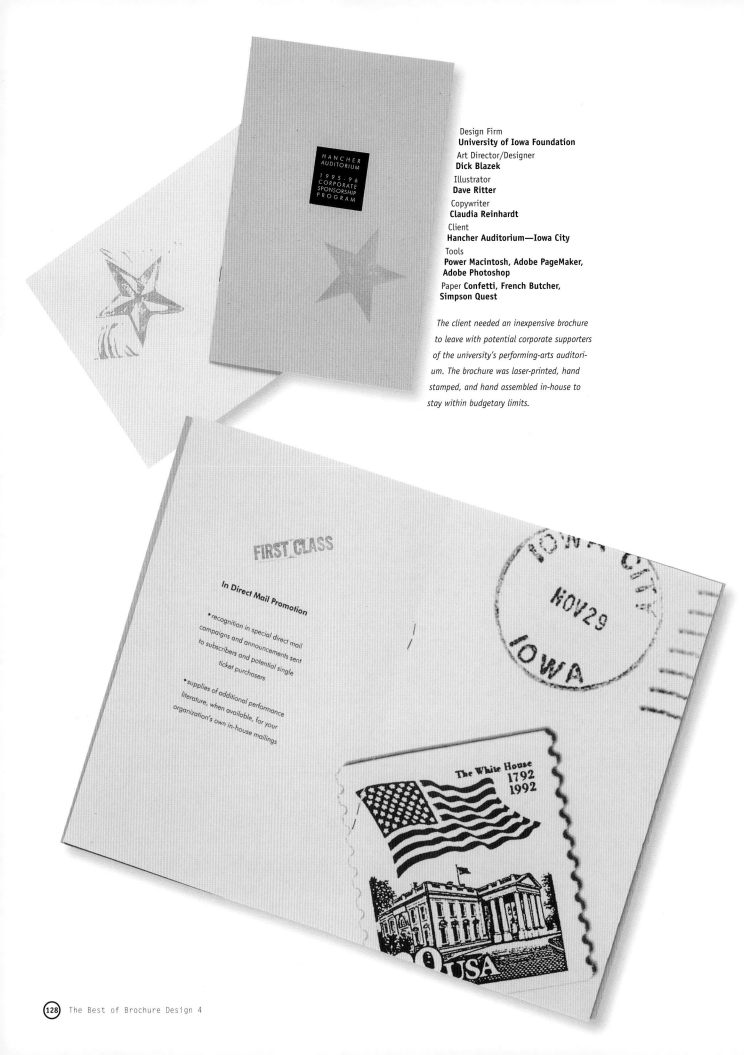

Design Firm
University of Iowa Foundation

Art Director/Designer
Dick Blazek

Illustrator
Dave Ritter

Copywriter
Claudia Reinhardt

Client
Hancher Auditorium—Iowa City

Tools
Power Macintosh, Adobe PageMaker, Adobe Photoshop

Paper **Confetti, French Butcher, Simpson Quest**

The client needed an inexpensive brochure to leave with potential corporate supporters of the university's performing-arts auditorium. The brochure was laser-printed, hand stamped, and hand assembled in-house to stay within budgetary limits.

HANCHER
AUDITORIUM

1995·96
CORPORATE
SPONSORSHIP
PROGRAM

FIRST CLASS

In Direct Mail Promotion

• recognition in special direct mail campaigns and announcements sent to subscribers and potential single ticket purchasers

• supplies of additional performance literature, when available, for your organization's own in-house mailings

The White House
1792
1992

USA

Design Firm **Parham Santana, Inc.**
Art Directors **Millie Hsi, John Parham**
Designer **Millie Hsi**
Copywriter **Diana Amsterdam**
Client **VH1**

Since the music channel was repositioned as
"VH1: Music First," a media and sales kit were
developed as "The Source—The Ultimate
Guide to VH1 and Music." The source contains
programming, demographic information, lay-
ers of quotes, inside information, postcards,
and a positioning statement to create a rich
"everything music" message.

Design Firm
Teikna
Art Director/Designer
Claudia Neri
Copywriter
Giovanna Sonnino
Client
Giovanna Sonnino-Planita
Tools
QuarkXPress, Adobe Photoshop
Paper/Printing
Fedrigoni/Three-color offset

This brochure is used to promote "Isn't it
Romantic?"—an independently made, award-
winning Italian film on love and friendship
between four characters. The author hands it
out at screenings and festivals.

different **options** for different people

CREATE THE PERFECT MATCH

Pfizer

Design Firm
Platinum Design, Inc.
Art Director
Kathleen Phelps
Designers
Kathleen Phelps, Kelly Hogg
Illustrator
Dan Yaccarino
Copywriter
Kwasha Lipton
Client
Kwasha Lipton
Tools
Power Macintosh 8100
Paper/Printing
**Vintage Velvet Remarque
cover/Enterprise Press**

This flip book was created to express the client's ability to provide a wide range of options for every individual. The illustrations communicate this message and are an eye-catching introduction to the brochure.

dependent care account

ad&d insurance

CREATE THE PERFECT MATCH

AND OTHER IMPORTANT THINGS YOU SHOULD KNOW.

Pfizer Pflex enrollment for 1996 is just around the corner, in
November. Whether you plan to change your current benefits
elections or stay with the coverage you have now, this year there
are short cuts to enrollment that can help you make
your selections more quickly and easily. Here's a preview.

short cuts

automatic enrollment
express enrollment
cuts enrollment time
a tried-and-true way to enroll

1 2 3

short cuts, TO YOUR 1996 PFIZER PFLEX ENROLLMENT...

Design Firm
Platinum Design, Inc.

Art Director/Designer
Kathleen Phelps

Photography
Steve Ladner

Copywriter
Kwasha Lipton

Client
Kwasha Lipton

Tools
Power Macintosh 8100

Paper
Strathmore 80 lb. text

This brochure was distributed to Pfizer employees to make them aware of the
annual benefits enrollment period. As well as announcing the beginning of enrollment,
it also introduced them to many new, quick options available for completing the process.
Each of the visuals used in the brochure shows a comical take on shortcuts, thereby
reinforcing the message. Vintage stock photography was used, with one additional photo
being staged and shot for the piece. The brochure was well received by the employees
and was a successful launch for the enrollment process.

Design Firm
Kiku Obata and Company
Art Directors
Terry Bliss, Pam Bliss
Designers
**Terry Bliss, Pam Bliss, Scott Gericke,
Eleanor Safe**
Photography
David Stradal
Copywriter
Carole Jerome
Client
AIGA—St. Louis

*This call for entries for the AIGA's Third
Annual Design Competition outlines the
fundamental techniques of competition
entry, and is patterned after Dale
Carnegie's popular book How to Win
Friends and Influence People. The parody
is carried throughout the piece with
numerous quotes from Carnegie's book
humorously applied out of context. The
promotional poster accompanying each
booklet was designed to look spontaneous,
adding to the overall sense of fun.*

Design Firm
Parham Santana, Inc.
Art Director
John Parham
Designer
Ron Anderson
Photography
Fred Charles
Client
BMG Video
Tools
Macintosh 8100/100

*Created for a newly formed video division,
this collage of the Bertelsmann Building in
New York City's Times Square positions the
company as a creative resource within a
media powerhouse.*

Design Firm
Rapp Collins Communications
Art Director/Designer
Amy Usdin
Copywriter
Brad Rouy
Client
3M

*The purpose of this guide was to inform and
comfort the survivors of 3M employees. With
3M's extensive benefits package, survivors
need to make important decisions regarding
the continuation of benefits. The tone of
the package has to convey the information
in a soothing and comforting manner. This
was accomplished by using elegant, rich
photography of natural subjects, a variety
of papers, and simple, stark typography.*

3M Survivor Benefits

Changing Tides

The future doesn't have to seem cloudy.

It can be strong and bright. Tomorrow can
be filled with hope again. Tomorrow can be
filled with rain to help wash away the tears.
And light to help you see more clearly.
Through changes of nature we learn how
fragile life can be.

Protecting your future

Design Firm
Sayles Graphic Design
Art Director
John Sayles
Designer/Illustrator
Jennifer Elliott
Copywriter
Kristin Lennert
Client
Iowa Council for International Understanding
Paper/Printing
Chipboard/Screenprinting, offset printing

Una Noche de Fiesta was a fund-raiser with a Latin-American theme. A total of 1,500 invitations were produced for the Iowa Council for International Understanding's annual event, which enjoyed an outstanding turnout. Alternating pages of chipboard and bright paper were printed with colorful graphics and copy, and additional pages are burlap with tipped-on chipboard icons. The cinnamon stick used as binding was secured with jute twine, and the invitation was mailed in a cheesecloth drawstring bag. Additional campaign materials included a poster screenprinted on chipboard.

Design Firm **G.W. Graphics**
Art Director **Glenn Whaley**
Designer **Sue White**
Copywriter **Carl Schlanger**
Client **Southwestern Illinois Tourism Bureau**
Tools **Macintosh 9500, Adobe Photoshop, QuarkXPress**
Paper/Printing **Mohawk Satin White/Record Printing**

Because this was a fund-raising brochure, the client wanted to avoid a glossy, expensive look. Four-color subjects were limited to small photos on right-hand pages; full-page photos on left pages were manipulated in Photoshop to achieve the look of duotones. The budget wouldn't accommodate the grommet binding the client originally wanted, so saddle-stitched binding was covered with inexpensive single-faced cardboard for added interest.

HEAVEN

EARTH

MAN

Design Firm **Alan Chan Design Company**
Art Director **Alan Chan**
Designers **Alan Chan, Peter Lo, Pamela Low**
Copywriters **Margaret Tsui, Todd Waldron, Ann Williams**
Client **The Swank Shop, Hong Kong**
Paper/Printing **Daiici International Co., Ltd.**

The theme for the client's fall/winter brochure is based on the subject of environmental protection, which reflects the dedication of the Swank Shop. The concept of "Heaven, Earth, and Man" was adopted to represent the three key lines of business for Swank.

Design Firm
Sayles Graphic Design
Art Director
John Sayles
Designers
John Sayles, Jennifer Elliott
Illustrator
John Sayles
Copywriter
Andy Johnson
Client
American Institute of Steel Construction
Paper/Printing
Springhill/Offset printing

The brochure was intended to highlight a first-of-its-kind event in the industry that promotes the beauty of steel in architecture. The circular logo, designed with bold and geometric lines, doubles as a "seal" for the event. The brochure is wire-O bound with the event's name and logo embossed on the cover, and inside pages feature four-color photographs of buildings using steel, as well as steel textures scanned directly from actual pieces of metal. Over 5,000 brochures were mailed to architects and allied professionals.

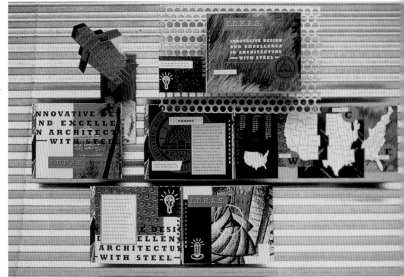

Design Firm
Witherspoon Advertising

Art Director/Designer
Randy Padorr-Black

Illustrator
Phil Boatwright

Client
Performing Arts Fort Worth

Creative Director
Debra Morrow

Paper/Printing
Zanders paper/Motherall Printing

Performing Arts Fort Worth required a high-end brochure to entice donations of $100,000 and above for a $60-million fundraising campaign for the last great performing arts hall built this century. The result was a sophisticated piece that wealthy donors could leave on their coffee tables so that their friends might peruse its contents and open their checkbooks. The campaign was hugely successful, raising the $60 million in three months.

Design Firm
Walsh and Associates, Inc.
Art Director
Miriam Lisco
Designer
Mark Ely
Copywriter
Karen Reed
Client
Empty Space Theater
Tools
Adobe PageMaker, Adobe Photoshop, Adobe Illustrator

The Empty Space Theater—featuring theater with an edge—has a twenty-five-year history in Seattle. The brochure presented a special challenge in portraying the theater's attitude without being able to include any specific images, since the piece was done in advance of the theater season being featured.

This Season at The Empty Space

November 21, 1996

School for Wives

by Moliere
translation by Richard Wilbur
Directed by Eddie Levi Lee
Opens November 21, 1996

We gave them Jerry Lewis and Jazz but, before that, France gave the world one of its most brilliant comic geniuses. Biting and satirical, wild and zany, Moliere means timeless comedy. The premise: an older man marries a much younger woman and plans to train her to be his vision of the perfect wife. Little does he know she has plans of her own. Add to this a fabulous translation by the famed Richard Wilbur and the highly physical comedic touches by our own mischievous Eddie Levi Lee and you have all of the ingredients for fun!

January 8, 1997

World Premiere Musical

World Premiere Musical
By Chris Jeffries
Opens January 8, 1997

One of Seattle's astonishing young musical talents makes his mainstage theatre debut. Chris Jeffries has written a variety of musical comedy pieces for Annex Theatre including *I See London, I See France* which won best musical awards from the *Seattle Times, Weekly* and *The Stranger* in 1995. His innovative music has been heard in productions at Alice B. Theatre and Bumbershoot. We forward to collaborating with him as he takes his talents in a new direction and explores more dramatic musical work at The Chris is currently drawing inspiration from the arresting works of Nathaniel Hawthorne, but who knows where the muse will lead...

Mandragola Unchained
1993 Joanne Klein & Whitney Lee

"...The Empty Space is a place for well-produced crowd-pleasers."
The UW Daily

1996–1997 SEASON

3

Design Firm **Sayles Graphic Design**
Art Director **John Sayles**
Designers **John Sayles, Jennifer Elliott**
Illustrator **John Sayles**
Copywriter **Wendy Lyons**
Client **American Heart Association**
Paper/Printing **Offset printed on Curtis Tuscan Terra, Tuscan Terracoat, Ultra II, Hopper Hots/Thermography, screenprinting**

To educate Iowa's children about heart-healthy lifestyles, a childlike illustration style of the graphics of hearts and faces that appear through the collateral pieces was chosen. The campaign includes a support brochure directed to individuals and corporations considering a contribution of $25,000 or more.

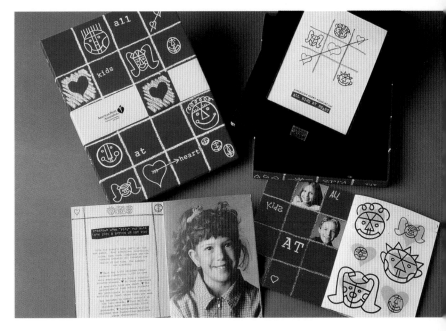

Design Firm
J. Graham Hanson Design
Designer
J. Graham Hanson
Client
American Express
Tools
QuarkXPress
Paper/Printing
**Simpson Starwhite Vicksburg,
six PMS colors**

*An awards booklet designed in 1995
to recognize 1994 winners, each of
five winning teams is identified by
an individual color designation
representing the autonomous and
separate nature of each team's
accomplishments.*

1994 Awards Program

AMERICAN
EXPRESS
QUALITY
PARTNERSHIP
AWARDS

QP⁸

American Express Travel Related Services

Closing the gap between where we are and where our employees, customers, and shareholders want us to be is a continuous process.

AEQL

American Express Quality Partnerships 8

Unified Customer Service Management System

A powerful combination of world-class
service and best-in-class cost efficiency was
attained by our Unified Customer Service
Management Team (UCSM) when they
improved our Risk Management System.
The team began by studying the root causes
of customer disputes, then designed a
program that is better for Cardmembers –
and is profit-based.

The new consolidated system resolves more
conflicts at the first point of contact, so
Cardmembers make fewer calls and receive
faster results. This has led to a striking
93% overall satisfaction rating with dispute
processing, with 46% of Cardmembers
surveyed saying they will use our Card
more frequently.

Karen Barlow
Marva Bezabeh
Annette Cardillo
Dan Casper
Shen Yiao Chang
Jean Chong
Damian Davila
Marisa·DiLenge
Robin Drews
Ricardo Dumornay
Paula Gosselin
Maria Nastacio
Rick Nowicki
Julieann Pegnataro
Dennis Phelps
Cheryl Potter
John Rathmanner
Arnie Rosentreter
Ray Sharp
Gail Shefield
Dick Spellacy
Michele Stueber
Yang Xu
Pat Yado
Tim Young

American Express Quality Partnerships 8

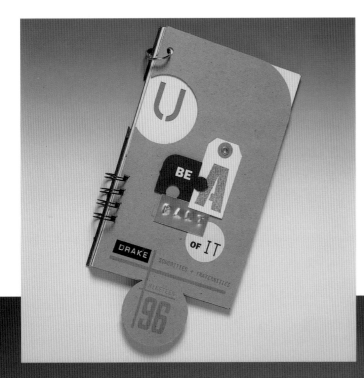

Design Firm
Sayles Graphic Design
Art Director
John Sayles
Designers
John Sayles, Jennifer Elliott
Illustrator
John Sayles
Copywriter
Kristin Lennert
Client
Drake University
Paper/Printing
Curtis Retreeve and chipboard/Offset, screenprinting, and thermography

Using the theme "Be a Part of It," the brochure for Drake University students participating in Greek fraternity and sorority membership uses a double-ply chipboard cover die cut in the shape of a puzzle piece. Inside the piece, a variety of printing and finishing techniques are used for graphics and copy, including thermography, embossing, die cutting, and offset printing. Hand-applied glassine envelopes contain additional information. The brochure is bound with wire-O binding and an aluminum ring.

Design Firm **XSNRG Illustration and Design**
Art Director **Brian Jamieson**
Designer/Illustrator **Kevin Ball**
Copywriter **Brian Jamieson**
Client **The Edge**
Tools **Picture Publisher, Adobe PageMaker**

A central theme at The Edge is "Research Outside the Box." With that in mind, a brochure was created with a box theme. Scans of suitable boxes provided the starting point for all the main panels. The piece was printed on non-gloss stock to maintain the box feel and the insert pages were initially simple photocopies, playing up a lower-tech feel that contrasts with the client's technical outlook. Reaction to the unusual nature of the piece has been very positive.

Design Firm
Vrontikis Design Office

Art Director
Petrula Vrontikis

Designer
Kim Sage

Copywriter
Carmen Ritenour

Client
Carmen Ritenour/CS Productions

Tools
QuarkXPress, Adobe Photoshop

Paper/Printing
Potlatch Vintage Velvet/Donahue Printing

This program brochure was created for a special event as a musical tribute to the late Antonio Carlos Jobim. A variety of photos were provided to create a timeline and illustrate the piece. The duotones were created in QuarkXPress and each spread incorporates a letter of Jobim's name. Potlatch Paper liked the piece so much that they reprinted 30,000 of them to show off their vintage gloss grade of paper.

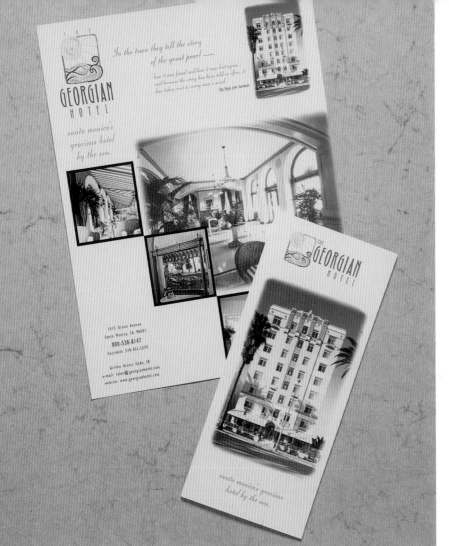

Design Firm
Vrontikis Design Office
Art Director/Designer
Petrula Vrontikis
Photo Retouching
Mimi Archie
Copywriter
Miranda Craig
Client
Dan League/The Georgian Hotel
Tools
QuarkXPress, Adobe Photoshop
Paper/Printing
Vintage Velvet/Graphic Arts Center

The Georgian Hotel is a wonderful Art Deco-era hotel in Santa Monica. The color photographs supplied by the client were of inferior quality and were inconsistent in lighting and style. Using the photographs as a starting point, they were refined in Photoshop, mimicking the old hand-tinting technique used in the Art Deco era. The client was absolutely thrilled that such an authentic and consistent look was created with the photography, the primary element used in the brochure.

Design Firm
Kaiserdicken
Art Directors/Designers
Debra Kaiser, Craig Dicken
Illustrator
Zoe Papas
Copywriters
Erin Garrett, Shaun Matthews
Client
Twin Farms #1
Tools
Macintosh
Printing
W. E. Andrews

The client's first intention for this brochure was to give it a literary influence. The double Japanese-fold book was done as both a design element and to bulk the brochure so it could be perfect bound. The majority of the images are illustrations since the property was being renovated and new construction was taking place during design and production.

MEADOW COTTAGE

Meadow Cottage, true to its name, rests at the top of a pastoral wildflower meadow. Embracing this setting, its Vermont clapboard exterior offers no hint of what lies within. Entering this evocative Moroccan scene, it is reminiscent of a desert king's traveling palace. An inglenook fireplace of intricate mosaic tile work is framed by upholstered banquettes of a bright multi-colored pattern. Moucharaby screens embellish the windows, tracing lacy shadows upon the terra cotta floors. Step down into an enchanting bed-chamber with hand wrought bronze columns supporting a magnificent tented ceiling suspended from which is a thirteen light, pierced tole chandelier of colored glass. Bathe in this intoxicating atmosphere in a glazed nook surrounded by a stand of white birch.

WILD EMPIRES OF FLOWERS ROSE UP IN THE MEADOW.
AND BY GOLDEN SEPTEMBER THE TWISTY-TREED ORCHARD
WAS CREAKING WITH APPLES.

24

Design Firm
Kaiserdicken
Art Directors/Designers
Debra Kaiser, Craig Dicken
Illustrator
Zoe Papas
Copywriters
Erin Garrett, Shaun Matthews
Client
Twin Farms #2
Tools
Macintosh
Paper/Printing
W. E. Andrews

*This second brochure for an exclusive
hotel allowed for the use of photos since
construction was completed. On the cover,
an abstract image was used rather than
trying to represent the property or style of
accommodations, since the style from
cottage to cottage varies drastically.*

Design Firm
Storm Deign and Advertising
Consultancy
Art Directors/Designers
David Ansett, Dean Butler
Copywriter
LD and A
Client
Swinburne at Lilydale
Paper/Printing
Silk matte/Four-color process

This showcase brochure for a
University features the concept of
"schooling and industry meet with
success." Art-directed photos along
with mixed, simple typography
and modern colors all add to the
effect of the piece.

A new landmark
for the outer east

Lilydale is also central to a region whose boundaries are Ringwood and Knox
to the west and south, Healesville and the Dandenongs to the north and east.

The region boasts a burgeoning employment market, with new
employers recognising the value of a growing population, the right
mix of land price and availability, the region's significant potential
for new investment and its desirability as a workplace.

Having a university of Swinburne's stature is now a strong
additional consideration, given the fact that Swinburne
has one of the finest graduate employment records
in the country.

And the region is home to a younger than average
population, a generation needing further educational
qualifications as their passport to future employment.

The new campus itself will serve both as a landmark and heart to the
region. Located on a 24-hectare hilltop site, overlooking the
Lilydale Lake, it commands stunning views of the area, a key
consideration in Glenn Murcutt's design for the first University
building.

It has a readily identifiable focus in a breathtaking, three storey,
multi purpose building complex, which houses everything from
computer laboratories, classrooms and a library facility, to lecture
theatres, recreational facilities and a bookshop.

Festival of the Arts
Friday, February 21, 8pm
Free Event!

Dance, film, music, theater, and visual art and design come together in this gala celebration of the year's most exciting student work from CSULB's prestigious College of the Arts. Don't miss the premiere of this new Carpenter Center tradition, our way of introducing the artists of tomorrow.

National Traditional Orchestra of China
Saturday, March 15, 8pm
Tickets: $18 and $15

This performance is not only the Orchestra's West Coast debut, but also the West Coast premiere of a new work for cello and traditional orchestra composed by Chinese-American musician Bright Sheng, and commissioned by Carnegie Hall. The 60-member National Traditional Orchestra of China draws its vast repertoire from five millennia of folk music from China's diverse regions, as well as more contemporary works by Chinese and European composers.

Richard Carpenter
Friday, February 14 and Saturday, February 15, 8pm
Tickets: $30, $25 and $20
$5 discount for students and seniors

Join Carpenter Performing Arts Center Founding Benefactor and CSULB alumnus Richard Carpenter in an evening of Carpenters' hits, classical music, and special footage of Karen Carpenter. This special concert kicks off Richard Carpenter's new world tour.

Tokyo String Quartet
Saturday, February 22, 8pm
Tickets: $18 and

One of the most highly praised chamber ensembles in the world, the Tokyo String Quartet exhibits extraordinary technical command and dynamic style. These stellar performers for a program of dynamic style. Quartet in B-flat Major, D. 112 (Op. 168), Debussy's String Quartet in G minor (Op. 10), and Brahms' String Quartet in C minor (Op. 51, No. 1. Presented in association with the CSULB Department of Music.

Lewitzky Dance Company
Saturday, May 17, 7pm
Tickets: $37 and $30
A Final Performance Tribute

Bella Lewitzky, Los Angeles' grande dame of modern dance for over 30 years, is honored at this final performance of her company which closed after the 1996-97 season. This extraordinary evening features the newly commissioned work Four Women in Time, excerpts from her expansive choreographic repertoire, appearances by former Lewitzky dancers, and a special tribute to Bella. The Richard and Karen Carpenter Performing Arts Center is proud to co-present this very special tribute.

Harriet and Charles Luckman Fine Arts Center
Gala information only: (213) 580.6338

Spring 1997 Season

Richard and Karen Carpenter Performing Arts Center

Design Firm
CSULB

Art Directors/Designers
Eng Tang, Steve Chow

Copywriters
Eng Tang, Steve Chow

Client
Carpenter Arts Center (CSULB)

Tools
Adobe Illustrator, Adobe Photoshop

Paper/Printing
Choice

The backbone of this piece is the heavy manipulation of images in Photoshop and the creative treatment of type in Illustrator.

Design Firm **Held Diedrich**
Art Director **Dick Held**
Designer **Megan Snow**
Photographer **Larry Ladig**
Client **Marian College**
Tools **QuarkXPress, Adobe Photoshop**
Paper/Printing **Remarque Vintage/
Offset printing**

*This brochure for the campaign for Marian College is the
primary vehicle in a campus fund-raising effort. A mixture
of alumni, program offerings, and future plans were fea-
tured to give prospective donors the big picture.*

THE CAMPAIGN FOR MARIAN COLLEGE

THE CAMPAIGN FOR MARIAN COLLEGE

The Campaign for Marian is seeking $8 million in new philanthropic investments to accomplish four very basic...

Total Goal: $3,252,000

Bringing coherence to the campus and improving
residence halls will do more than enhance Marian's
appearance—it will physically embody the cohesive
spirit of the Marian community. As a result, Marian
will be better able to attract and retain quality
students, an important part of the college's strategic
plan. The three historic estates which comprise the
campus will be integrated, and a new sense of physical
connection—a "college forum area"—will foster
student, faculty and staff interactions and energize
the college in exciting ways.

Funds are sought to:

• Build a new Marian Forum, completely
landscaping the center of campus and
creating an attractive student plaza as a
main focus of campus life. A new perimeter
road will connect the entire campus,
including new parking lots to be created
in convenient locations.

Goal: $1,680,000

• Modernize Marian's three residence facilities
by upgrading plumbing and furnishings in
St. Francis, Clare, and Doyle Halls.
The college must modernize these halls and
make them more comfortable in order to
remain competitive with similar institutions.

Goal: $1,570,000

PROPOSED MARIAN COLLEGE F...
view from main entry

M
C

*Groundbreaking in 1947 for Clare Hall and the Administration/Science
building. Participants included Archbishop Paul C. Schulte;
Mother M. Clarissa Dillhoff; Sr. Mary Cephas Keller, Mother General
and president of Marian's board of trustees; and the Very Rev. Msgr.
Francis J. Reine, theology instructor and later Marian's president.*

Design Firm **Swieter Design U.S.**
Art Director **John Swieter**
Designers **John Swieter, Julie Poth**
Illustrator **Gary Kelley**
Copywriters **Mary Woods, Elaine Vitt**
Client **YPO**
Tools **Adobe Illustrator, QuarkXPress**

This piece a brief organization overview
directed toward prospective members of the
Young Presidents' Organization. YPO is a
global organization of President's and CEOs.

Other speake[...] [...]ck, Jack Kemp, South African
President Nels[...] [...]ator John McCain, business expert Stan
Davis, humanita[...] Mother Teresa, anthropologist Jane Goodall and
former CIA Director Robert Gates.

PRESIDENTS' FORUM
Close to home you can experience the ultimate opportunity
for idea exchange — Presidents' Forum. Small groups of members
or spouses, under the guidance of a trained member moderator,
meet regularly to discuss personal or professional topics in the
strictest confidentiality.
The value of honest and objective feedback from forum has been so
fulfilling for members that more than 80 percent belong to a forum.
Some participants describe it as "the primary personal benefit" they have
had in YPO; while others say it has introduced them to the "highest levels
of trust, respect and friendship."
YPO provides Moderator Training Programs and Forum Officer
training throughout the year to facilitate forum.

YPO MEMBERS LEAD ALL TYPES OF BUSINESS

.6% AGRICULTURE
1.1% MINING
.4% CONSTRUCTION
.2% MANUFACTURING
5.2% TRANSPORTATION
15.4% WHOLESALE TRADE
17.8% RETAIL TRADE
17.6% FINANCE
15.9% BUSINESS SERVICES
.9% PUBLIC ADMINISTRATION
4.2% NOT CLASSIFIED

8

Not only can it involve
you in tremendous growth
and learning, but it is an
opportunity for your
children to be exposed to
an international experience
that they would never
get otherwise.

—CAROLYN SMOLLAN
Johannesburg

9

Design Firm
Werk-Haus
Art Director/Designer
Ezrah Rahim
Copywriters
Hani Ahmad, A.A. Hanan
Client
YTL Corporation
Printing
Four-color process

The project involved design of a souvenir brochure and packaging design for the Malaysian Crystal Rainforest Evening. Concert design and execution were accomplished in three weeks in time for the Gala Evening of the Malaysian Rainforest Awareness Week. The piece successfully conveyed YTL Corporation's awareness for the environment.

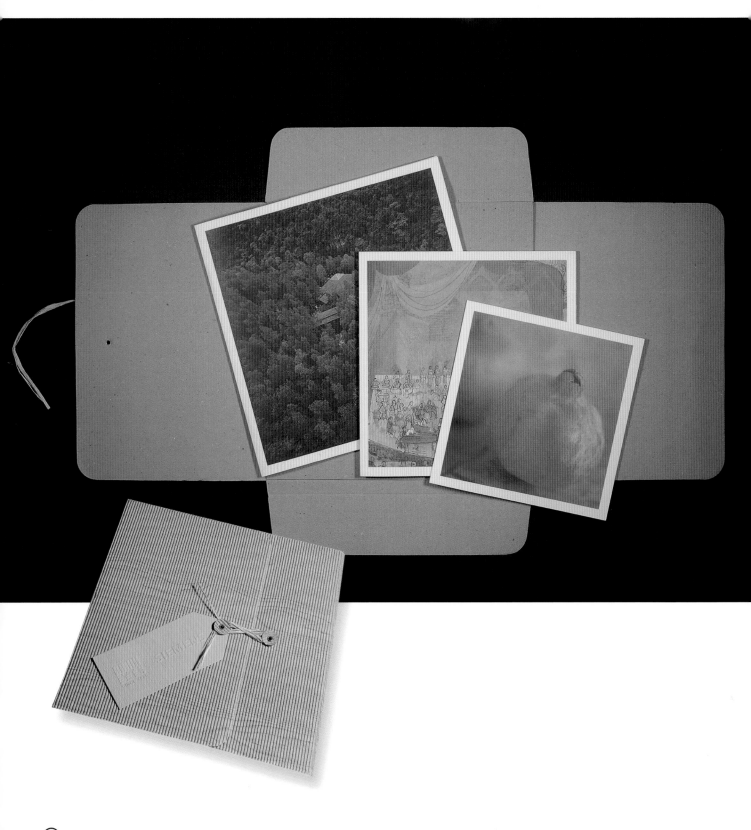

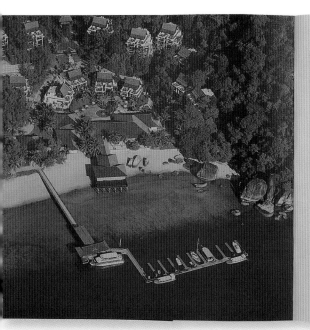

THE CROWN JEWEL of YTL's hotels and resorts is
Nestled between the islands of Sumatra to the west, Java to the sou
legendary location lends an air of mystic and history.

The architectural and interior designs of the resort's hill and sea
Southeast Asian cultures gave the designers challenging opportunities to
The hill villas are built on the edge of the rainforest and the sea villas on
The resort was created to blend in with the natural environment with the intention of preserving the ecosystem and
splendour of the island's virgin rainforest. At least 95 per cent of the island's 3 million year old rainforest has remained
untouched by development.

PANGKOR LAUT RESORT

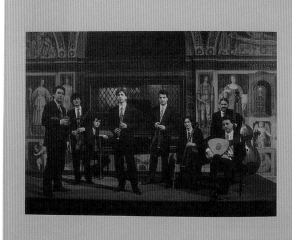

IL GIARDINO

THIS YOUNG enthralling chamber ensemble from
reputation for its innovative and exciting interpretation of ear

Il Giardino Armonico, formed in 1985 was founded by G ca and Paolo
Beschi, affectionately known as the 'harmonious gardeners'.

Led by Antonini, the ensemble has concentrated its musical the baroque era performing
on original instruments. Formation varies from 3 to 20 players. Members from the ensemble perform
regularly with famous 'early music movement' musicians like Harnoncourt, Leonhardt, Pinnock and
Sawall.

Included in Il Giardino Armonico's expanding repertoire are compositions by great baroque mas-
ters like Vivaldi, Bach, Purcell and Handel.

Critics have hailed Il Giardino Armonico for its 'unconventional and bold style', 'rough-and-tumble
but always thrilling string sound', imbued with Italian elegance and humour rather than the dreariness
of concert-halls, 'Armani and Versace instead of tails and white tie.'

Always a welcome visitor to major national and international music festivals, the ensemble has
been highly acclaimed for its recording of Vivaldi's The Four Seasons.

It has also produced several other outstanding recordings such as Musica da Camera a Napoli, a
tribute to the musical city of Naples and Vivaldi's complete Concerti da Camera for which it received the
prestigious Antonio Vivaldi Prize.

Il Giardino Armonico is presently working on J.S. Bach's Brandenburg Concertos on an exclusive
contract with Teldec. Important concert tours scheduled for 1996 include performances in Germany,
Spain, France, United Kingdom, Japan and U.S.A.

Design Firm
David Carter Design
Art Directors
Sharon LeJeune, Lori B. Wilson
Designer
Sharon LeJeune
Photography
George Contarakes, Michael Wilson
Copywriter
Melissa Gatchel-North
Client
Sun International Ocean Club
Paper/Printing
Mohawk/AZ dryography

The Ocean Club is a small, intimate resort on Paradise Island in the Bahamas. The brochure was designed to create a romantic mood with black-and-white photos of the property mixed with color photos of couples enjoying the resort's atmosphere. The copy is minimal with only lines of poetry to continue the romantic tone of the piece. A smaller eight-panel flyer was created for mass-mailing and both were printed in English and French.

Stanchions of time - resurrected from a place far away - rise to greet world-weary travelers.

Surrender under their domes, and feel your body, mind and soul restored.

There is a place where sapphire skies and turquoise waters meld into glorious days. A place where night falls as softly as black velvet. Here, beauty is Measured in grains of sparkling sand. And every sunset is liquid gold. It is a place where secluded gardens provide a secret retreat. Starry romance is a Nightly adventure. And discerning attendants fulfill every wish. Within the serenity of this private island estate, luxury is every visitor's reward. Here paradise is found. The Ocean Club. Paradise Island, Bahamas.

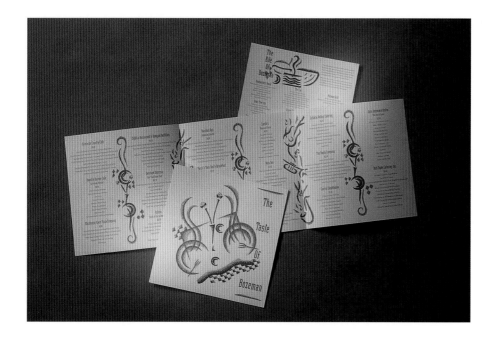

Design Firm
Palmquist and Palmquist
Art Directors/Designers
Kurt Palmquist, Denise Palmquist
Illustrator
Kurt Palmquist
Client
The Taste of Bozeman
Tools
Adobe Photoshop, Adobe PageMaker
Paper/Printing
Classic Laid/Two-color offset

The goal was to create a promotional brochure as well as a menu to promote a special event for a group of restaurants. The event includes a wide variety of styles of food so no one type could be featured, yet food had to remain the focus of the piece.

Design Firm
Kaiserdicken
Art Directors/Designers
Craig Dicken, Debra Kaiser
Client
Turtle Island
Tools
Macintosh
Printing
Lilyfield Printing, Ltd.

The focus for this promotional piece for an exclusive resort located in Fiji was to give the brochure a light and airy look with lots of white space.

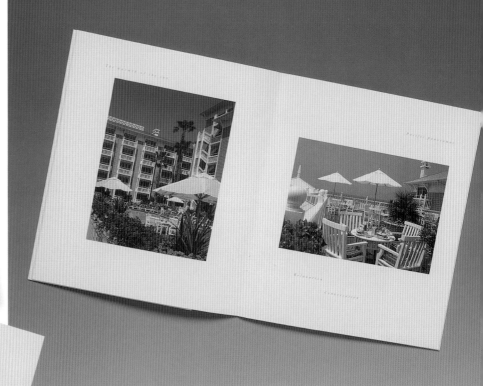

Design Firm
David Carter Design
Art Director/Designer
Lori B. Wilson
Photography
Klien and Wilson
Copywriter
Max Wright
Client
Shutters on the Beach
Printing
Williamson

To establish a unique impression for this beach-side bungalow in Santa Monica, CA, the brochure's slipcover jacket was printed directly onto sailcloth. The subtle striping reflects the feeling of the awnings found on the property. Conventional offset printing was used with a 300-line screen.

▶ Design Firm
David Carter Design
Art Directors
Lori B. Wilson, Gary LoBue Jr.
Designer
Gary LoBue Jr.
Copywriter
Melissa Gatchel-North
Client
Christian Tours

The brochure was designed to promote cruise vacations for Christians. A translucent cover sheet was introduced to pique interest and to incorporate the company's concept statement. The piece was printed waterless with coordinating tritones.

The Annabelle
PAPHOS, ZYPERN

The Annabelle
PAPHOS, CYPRUS

Design Firm
David Carter Design
Art Directors
Sharon LeJeune, Lori B. Wilson
Designer
Sharon LeJeune
Copywriter
Melissa Gatchel-North
Client
The Annabelle—Thanos Hotels
Printing
Padget Press

The brochure's oversized format
displays the beautiful photography of
this world-class destination on the
tiny island of Cyprus. The large
brochure was printed in two languages
and the smaller version, for travel
agents, was printed in five languages.
The brochure was then adapted to an
eight-panel format for mass-mailing in
five languages. All were printed water-
less using a 300-line screen.

Design Firm
Mammoliti Chan Design

Art Director
Tony Mammoliti

Designer
Chwee Kuan Chan

Illustrator
Chwee Kuan Chan

Copywriter
National Gallery Society of Victoria

Client
National Gallery Society of Victoria

Tools
Adobe Photoshop, QuarkXPress

Paper/Printing
**Coated recycled
paper/Four-color offset**

*The intent for the design of the NGSV
membership brochure was to attract
younger members by using strong
contrasting colors. To maintain the
integrity of the original art, paintings
were shown in their entirety.
The client was extremely pleased with
the finished product.*

Design Firm
Lee Reedy Creative

Art Director/Designer
Lee Reedy

Client
Colorado Healthcare Association

Tools
QuarkXPress

*This packet of brochures promotes the annual
convention. The butterfly graphic symbolizes
the ageless theme of health care.*

Design Firm **Impress SAS**
Client **Zonco SNC**
Tools **Macintosh**

To celebrate the client's first 100 years of business, the brochure featured the client's name prominently and included ten varieties of paper and a metal cover to make a connection to the various machines produced by the client.

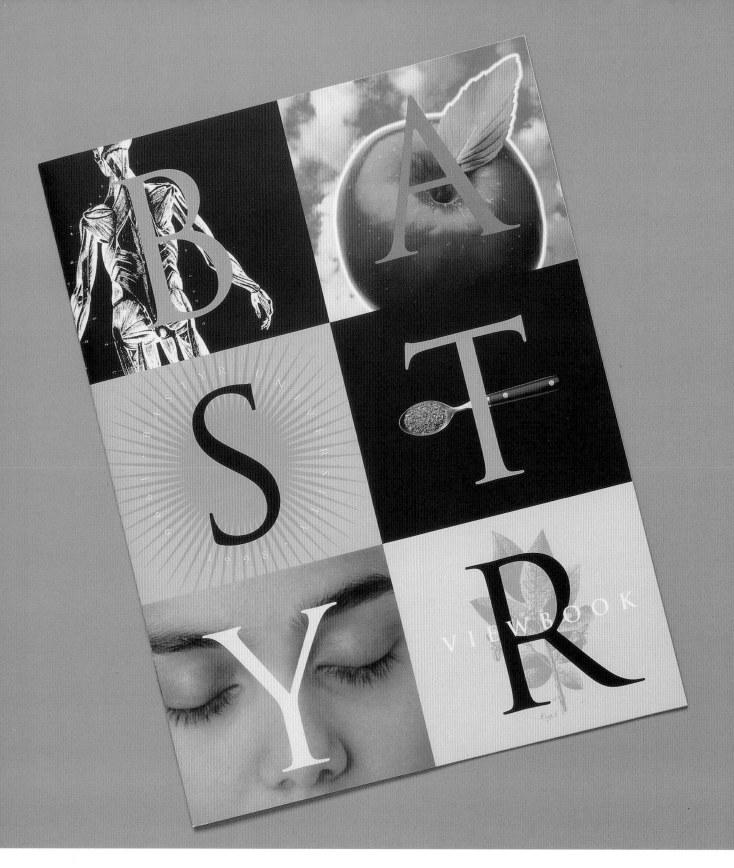

Design Firm **Widmeyer Design**
Art Director **Dale Hart**
Designer **Tony Secolo**
Illustrator **Tony Secolo**
Photography **Don Mason, Randy Albrighton**
Copywriter **Bastyr University**
Client **Bastyr University**
Tools **Power Macintosh, Adobe Photoshop, Adobe PageMaker**
Paper/Printing **Pace Setting/Four-color varnish**

Bastyr University is a college offering courses in natural medicine, herbal remedies, and holistic approaches to human health. The brochure includes interviews with faculty and students featuring their experiences studying and teaching at Bastyr. Degree program descriptions, course offerings, schedules, and tuition costs are included in the booklet.

SOUTH|SOUTH
CO-OPERATION

Malaysia

South Africa

ON 24TH AUGUST, 1995, ...

Guguletu, Cape Town

Richmond Farm, Durban

Incremental Housing

City Apartments, Pretoria

The Malaysia~South Africa
Friendship Housing Project

Design Firm
Werk-Haus

Art Director/Designer
Ezrah Rahim

Copywriter
A. A. Hanan

Client
YTL Corporation

Printing
Two-color offset

*This launch brochure took the form of a
leaflet and was produced in five days
going from manuscript to finished piece.*

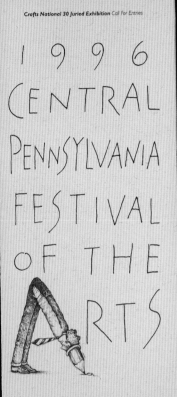

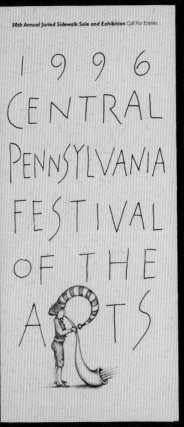

Crafts National 30 Juried Exhibition *Call For Entries*

1 9 9 6
CENTRAL
PENNSYLVANIA
FESTIVAL
OF THE
ARTS

30th Annual Juried Sidewalk Sale and Exhibition *Call For Entries*

1 9 9 6
CENTRAL
PENNSYLVANIA
FESTIVAL
OF THE
ARTS

Images 96 Juried Fine Arts Exhibition *Call For Entries*

1 9 9 6
CENTRAL
PENNSYLVANIA
FESTIVAL
OF THE
ARTS

1996 Banner Competition *Call For Entries*

1 9 9 6
CENTRAL
PENNSYLVANIA
FESTIVAL
OF THE
ARTS

Design Firm
Sommese Design
Art Director
Lanny Sommese
Designer
Marina Garza
Illustrator
Lanny Sommese
Copywriter
Phil Walz
Copywriter
**1996 Central Pennsylvania
Festival of the Arts**
Paper/Printing
Hammermill 70 lb./Offset printing

This series of call-for-entry brochures for an annual summer festival of the visual and performing arts includes a fresh graphic and pen-and-ink images that were scanned in with type layout in QuarkXPress. Brochures folded to 4" x 9" to fit into #10 envelopes for direct mailing or placement in racks throughout state.

Design Firm
Cato Berro Diseño

Art Director
Gonzalo Berro

Designers
Gonzalo Berro, Esteban Serrano

Client
Casa FOA

Tools
Adobe Illustrator

This brochure was commissioned for the most important exhibition of architecture and decoration in Argentina.

Design Firm
Sovereign Creative Group, Inc.

Designer
Richard Class Baerga

Client
YMCA San Juan, Puerto Rico

Printing
Ramallo Brothers

This institutional brochure is intended to raise funds for facility expansion.

 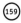

Art Directors
Daniel Bastian, Andreas Weiss
Illustrator
Henning Diers
Client
Junges Theatre Bremen
Tools
QuarkXPress
Paper/Printing
Recycled paper/Offset

"Night of Murders" is a theater piece in
which children plan to murder their parents.
The dark, scary feeling was augmented
by a special effect: a stamping machine
to simulate the murder.

DIE NACHT DER MÖRDER

Lalo: Lutz Gajewski
Beba: Nomena Struß
Cuca: Judica Albrecht

Clubs & Shows
concerts
Libra-Tes
tickets
TV Program Guide
Film reviews
School Net
Sports
Theatre
Weather Reports
Personal Guides
Travel
Sporting events
Music
Hit feature m
games
Wholesale
previews
University educatio

Music listening
Financial News
Specialty retail
Maps
Educational games
Film Classics
Single-Player Games
Political news
Sports Talk
Sports Merchandising
Restaurants
Educational events

TODAY, AMAZING.

TOMORROW, ASTONISHING.

We now stand poised at the next tremendous change: interactive, high-speed, full-service networking. Drawing on the strengths of the technologies that came before it, interactive networking encompasses a rich mix of print, sound, and moving pictures that surpasses its predecessors. Users command a vast array of resources and programming with the simplest of devices: the remote control for their television.

The ultimate goal of interactive programming is to maintain user interest and comfort. Whether the user is watching movies, catching up on world events, researching technical information, or participating in games, the best interactive content is compelling, intuitive, and polished.

The future arrived early.

MOVIES
98
97 99
94

Imagine that.

Design Firm
Silicon Graphics Creative
Art Directors
Amy Gregg, Michael Cronan
Designers
Amy Gregg, Meg Frost, Molly Castor
Copywriter
Doug Cruickshank
Client
Interactive Digital Studios
Tools
Macintosh, QuarkXPress, Adobe Illustrator, Adobe Photshop
Paper/Printing
Lustro 120 lb./Offset

This brochure was the premiere piece of marketing communications material produced by IDS. The group needed to make an impressive introductory splash at a high profile trade show. The brochure also need to convince potential customers that the company was offering viable technology products.

FCB ADVERTIZING. AACGOWAN DIG!

...T. YOU WILL FEEL RELAXED... VERY RELAXED. DIAL 213 258 0987. TALK TO

YOU KID

BIG BROTHERS & SISTERS

SOLUTIONS IN TUNE WITH YOUR COMPANY

1.. SPIN · DIAL · 4 · PIX
2.. DIAL · # · 4 · LYN
3.. PIC · LYN · 4 ·

Lyn Maye

VISIONS of the HEARTLAND

A RANDOM TES
 DESIGN AND

B COLLECTION S
 MANAGEMENT

C MEDICAL REVI

D EDUCATION AN

E STRATEGIC DAT

self-promotional
b r o c h u r e s

They must literally leap off the page
and into your customers mind

Your ideas or products must come alive

Allow them to touch, feel, hear and experience your ideas
and you leave a powerful message with a lasting impression

Today the successful way to reach your clients
requires multi-dimensional efforts

is our dimensional

Design Firm **Ribit Productions, Inc.**
All Design **Danna Stuart**
Copywriter **Ronda Bailey**
Client **Staff**
Tools **Adobe Photoshop, Adobe Illustrator, QuarkXPress**
Paper/Printing **Ikonofix dull/Buchanan Printing**

*This self-promotional brochure was used to explain interactive
media to prospective clients, and how it can be used in their
business. The creative idea was to take an old idea and bring it
to life, much in the way interactive media does.*

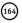

Design Firm **Television Broadcasts Limited**
Art Director **Alice Yuen-wan Wong**
Principal Designer **Agnes Pik-ying Chan**
Designer **Ka-po Chau**
Client **TVBI Company Limited**
Tools **Macintosh**
Paper/Printing **Matte art paper/Four-color process**

The TVBI Media Sales Kit is designed to present the image of TVBI as a global leader in the Asian TV industry, not just in programming supply, but in the creation of media sales activities throughout the world. The worldwide coverage of TVBI TV series is fully incorporated in the sales inserts with the reoccurring globe graphic.

Design Firm **Northern Illinois University**
Art Director **Carol M. Benthal-Bingley**
Copywriters **Peggy Doherty, Jerry Meyer**
Client **NIU Art Museum**
Tools **Adobe PageMaker,
Adobe Photoshop**
Paper/Printing **Curtis flannel
cover/Riverstreet Press**

*This piece was designed to showcase NIU
alumni artists who were brought together for a
group show celebrating NIU's centennial.*

▶

Design Firm **Hans Flink Design, Inc.**
Art Director **Hans D. Flink**
Designers **Hans Flink and Staff**
Client **Hans Flink Design, Inc.**
Tools **Power Macintosh, Adobe Illustrator, Adobe Photoshop**
Paper/Printing **Utopia Premium/Five-color offset**

*This self-promotion brochure for a design firm features a bold and simple format
with large, full-spread photography of past assignments that help to bring the
piece beyond its pages.*

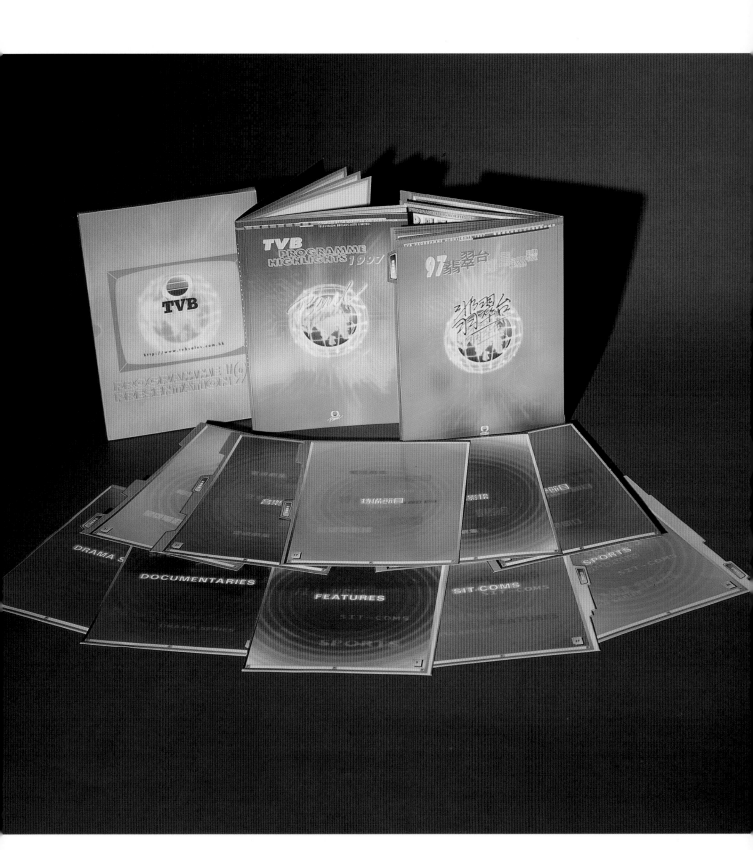

Design Firm **Television Broadcasts Limited**
Art Director **Alice Yuen-wan Wong**
Principal Designer **Sai-ping Lam**
Designers **Kenneth Ping-him Fung, Kingslie Wai-king Chan**
Client **TVBI Program Highlights 1997**
Tools **Macintosh, Adobe Photoshop, Macromedia FreeHand**
Paper/Printing **Tracing paper and art paper/Offset printing**

The brochure "TVBI Program Highlights 1997" is designed to convey the image of the World Wide Web. Tracing paper and a die-cut index were used to present the concept of stratification.

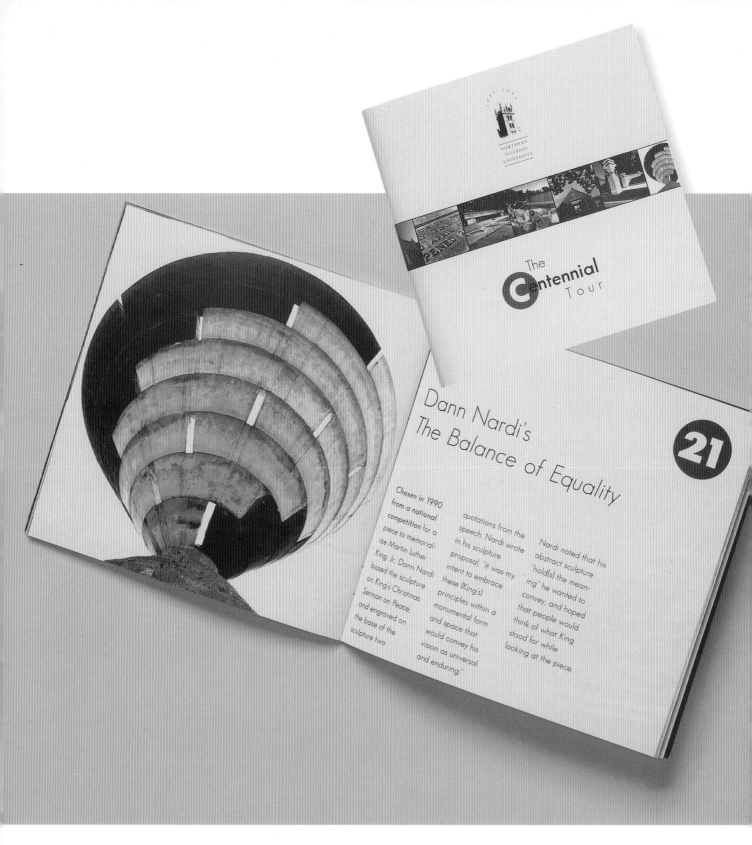

NORTHERN ILLINOIS UNIVERSITY

The **C**entennial Tour

Dann Nardi's
The Balance of Equality

21

Chosen in 1990 from a national competition for a piece to memorialize Martin Luther King, Jr., Dann Nardi based the sculpture on King's Christmas Sermon on Peace, and engraved on the base of the sculpture two quotations from the speech. Nardi wrote in his sculpture proposal, "It was my intent to embrace these [King's] principles within a monumental form and space that would convey his vision as universal and enduring."

Nardi noted that his abstract sculpture "hold[s] the meaning" he wanted to convey, and hoped that people would think of what King stood for while looking at the piece.

Design Firm **Northern Illinois University**
Art Director **Carlos Granados**
Designer **Tadson Bussey**
Photographer **Scott Walstrom**
Client **NIU Finance and Facilities**
Tools **Adobe PageMaker**
Printing **Creekside Printing**

This piece was designed as a "walking tour" to highlight campus landmarks for the school centennial.

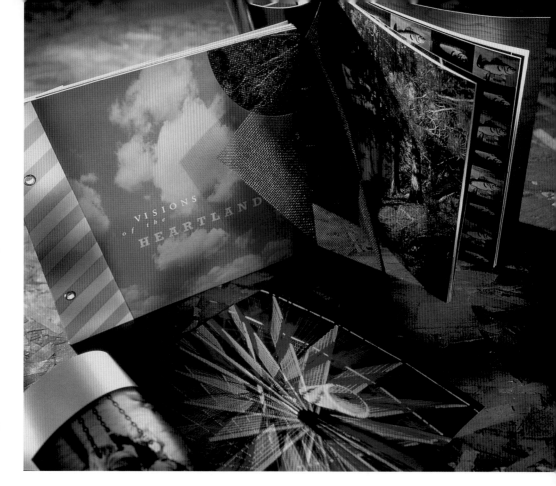

▶
Design Firm
Larsen Design and Interactive
Art Director
Tim Larsen
Designer
David Schultz
Client
Heartland Graphics
Printing
Heartland Graphics

Heartland Graphics wanted a promotional brochure that portrayed the company's quality printing capabilities and services as well as their midwestern roots. The brochure, "Visions of the Heartland," captures the essence of a Midwestern summer through the use of Midwestern photographers and a wide variety of printing techniques. These printing techniques gave the photographs an added element of texture and depth, and the piece as a whole conveyed its message effectively. It is the first in a series of brochures developed to capture the essence of life in the heartland.

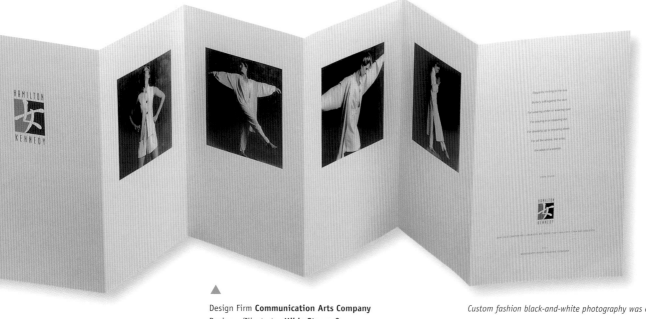

▲
Design Firm **Communication Arts Company**
Designer/Illustrator **Hilda Stauss Owen**
Copywriter **David Adcock**
Client **Mississippi River Trading Company**
Tools **Macintosh**
Paper/Printing **Kashmir/Offset lithography**

Custom fashion black-and-white photography was executed in black sepia duotones on natural Kashmir stock that mimics the color texture of the stonewashed silk of the clothing. The symmetrical layout relates well to the simplicity of the all-white classic line of lounge wear.

▶

Design Firm **Bo's Studio**
Art Director **Monica Cleveland**
Designers **Monica Cleveland, Adam Gudeon**
Illustrator **Adam Gudeon**
Copywriter **Adam Gudeon**
Client **Bo's Studio**
Tools **Macintosh, QuarkXPress,**
Adobe Photoshop
Paper/Printing **Rossi/Offset printing**

*Inspired by Latin-America folk artists' chap books
(small block-printed books with stories and poems),
this self-promotional and informational piece simu-
lates the block print using ink drawings that were
scanned and reworked in Photoshop. The font simu-
lates the rough look of the chap book text, which is
usually typed on old typewriters, and the recycled
paper successfully simulates the look of the paper
used by the chap-book artists.*

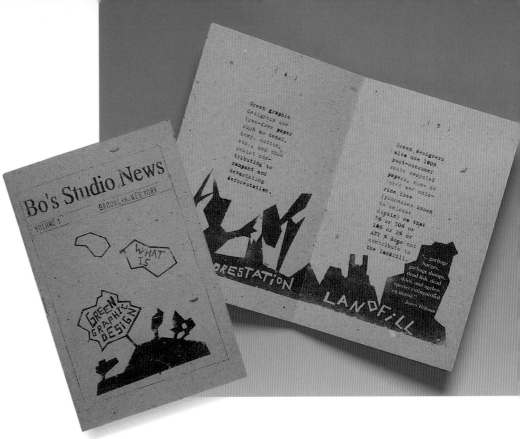

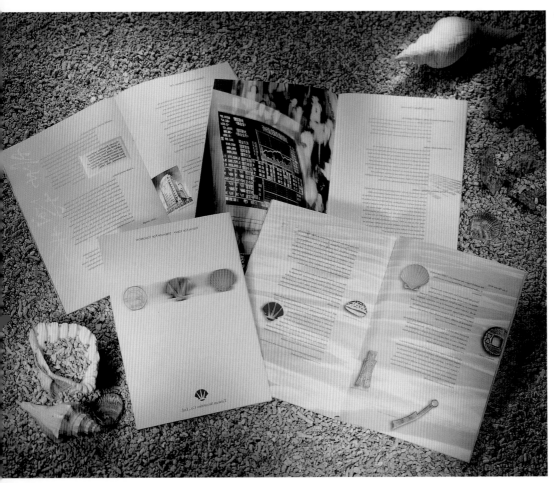

◀

Design Firm **Artailor Design House**
Art Director **Raymond Lam**
Designer/Illustrator **Vivian Yao**
Copywriter **Douglas Platt**
Client **Taiwan Securities Company, Ltd.**
Tools **Adobe Photoshop, Adobe Illustrator**
Paper **Zanders Paper**

*The story of the shell is the heart of the
brochure with the theme "Vision for Today,
Strength for Tomorrow" as the central theme
of the piece.*

foco media

This self-promotional brochure serves
both as an introduction to new media and
for communication of Foco Media's
services. The text and image material is
designed in modules to serve clients'
different interests and tasks. In addition,
the various modules function as the
base material for other self-promotional
media. In this way, Foco Media attempts
to achieve consistency of image
and content throughout all platforms
and media.

Design Firm **Foco Media Digital Media
Design and Production GmbH and Cie.**
Art Director/Designer **Steffen Janus**
Copywriters **Steffen Janus,
Christian von Sanden**
Client **Foco Media Digital Media Design
and Production Gmbh and Cie.**
Tools **Power Macintosh 7100, Adobe
Photoshop, QuarkXPress**
Paper/Printing **Cover, Luxosatin 300gm;
text, Luxosatin 170 gm/
Two-color offset**

Design Firm
Communication Arts Company
Art Director
Hilda Stauss Owen
Designer
Anne-Marie Otvos
Copywriter
David Adcock
Client
Singleton Hollomon Architects
Tools
**Macintosh, Adobe Photoshop,
Macromedia FreeHand**
Paper/Printing
Patina matte/Offset printing

*The brochure promotes the architecture
firm by featuring a variety of projects they
have worked on. The particular challenge
was to make the illustrations, which vary
in style, work well with the photographs.
All retouching was done in Photoshop while
the layout was done in Macromedia FreeHand.*

Design Firm **City of Moncton**
All Design **Judy Wheaton**
Copywriter **Judy Wheaton**
Client **City of Moncton—Gallery Committee**
Tools **Adobe PageMaker, Dynamic Graphics Clipper**
Paper/Printing **Supreme Gloss/TK Printing**

*With a prerequisite of two colors in two languages, this brochure for a
municipal government facility maintains the necessary contemporary look.*

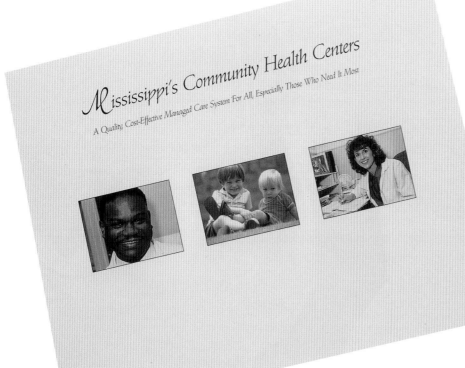

Design Firm
Greteman Group
Art Directors
Sonia Greteman, James Strange
Designers
Sonia Greteman, James Strange, Craig Tomson
Copywriter
Deanna Harms
Client
Greteman Group
Tools
Macromedia FreeHand, Adobe Photoshop
Paper/Printing
Chipboard, Moistrite Matte/Offset printing

This spiral-bound, hand-assembled brochure serves as an efficient self-promotional tool. Though small, it showcases Greteman Group's wide-ranging design capabilities quickly, easily, and comprehensively. The use of cardboard, corrugated material, and metal elements gives the highly tactile exterior a feeling of packaging—one of the firm's areas of expertise. Inside, beautifully photographed samples, simple typography, and GilClear division pages convey everything from signage to Websites.

Design Firm
Communication Arts Company
Art Director/Designer
Anne-Marie Otvos
Copywriter
Jeanne Luckett
Client
Mississippi Primary Health Care Association
Tools
Macintosh
Paper/Printing
Celesta dull cover, Sterling satin text/Offset printing

This brochure explains why Mississippi's community health centers will be great managed-care providers. In addition to promoting themselves in a positive light, the client also wishes to entice health-care professionals to join the team of Mississippi community health centers.

corporate profile

"Blackfish Creative took the time and energy to learn and understand our extremely diverse business. They are a strategic partner who we rely on for all our sales and marketing material."

Jim Hess, Marketing Manager
debis Financial Services, Inc.

Blackfish Creative Marketing, Inc. specializes in business-to-business communications. Our clients expect the highest level of creativity and a dedicated service ethic. Listening to the client and learning about their products, services and customers are important aspects of our work. We take the time to ask the right questions and learn how our clients do business. Then, we develop the best creative concepts and management approaches to achieve impressive results.

Blackfish Creative principals, Keith Danziger (l) and Drew Force. ▶

Blackfish Creative Marketing, Inc. © 1996

BLACKFISH
Creative Marketing, Inc.

annual profile

Design Firm
Blackfish Creative
Art Director/Designer
Drew Force
Illustrators
Juan Calvillo, Greg Kozawa
Copywriters
Keith Danziger, Drew Force
Client
Blackfish Creative
Tools
QuarkXPress, Adobe Photoshop
Paper/Printing
Warren Lustro dull/Bridgetown Printing Company

The goal was to create a promotional piece that allowed the work to speak for itself. A tint gloss varnish with 2% metallic silver was used as soft type on the cover and flysheets as well as on all photography.

Design Firm
Northern Illinois University
All Design
Carol Benthal-Bingley
Copywriter
Peggy Doherty
Client
NIU Art Museum
Tools
Adobe PageMaker, Adobe Photoshop
Printing
Riverstreet Press

*This art-museum calendar was produced
to mail as a brochure, but opens up to a
poster-size calendar.*

Design Firm **Buttgereit and Heidenreich,**
Kommunikationsdesign
All Design **Wolfram Heidenreich, Michael Buttgereit**
Copywriters **Wolfram Heidenreich, Michael Buttgereit**
Client **Alten-und Pflegehiem St. Josef**
Tools **Macintosh**
Paper/Printing **Coated paper/Four-color process**

The design of this brochure conveys eternal esteem for
senior citizens.

Herzlich Willkommen!

Alten- und Pflegeheim St. Josef

Beste Noten für Zimmer

Ein Zuhause mit
eigenen vier
Wänden. Und dazu
eine aufmerksame
menschliche und
medizinische
Betreuung. Was will
man mehr?

Gartenarbeit macht
Spaß und hält fit.
Bei uns können Sie
sich gern an
der frischen Luft
betätigen.

Auch für sportliche
Betätigung ist
unser Garten
bestens geeignet.
Da kommt die
Lebensfreude ganz
von selbst.

Für Kreislauf und
Wirbelsäule die
beste Medizin:
regelmäßig
schwimmen.
Machen Sie mit!

Zum Betreuungs-
angebot gehören
Senioren-Gym-
nastik, Sprudel- und
Kranken-Gym-
Massagebäder sowie
Fuß- und Haar-
pflege. Natürlich
dürfen Sie auch
eine individuelle
medizinische Pflege
erwarten. Unsere
Mitarbeiter sind
hervorragend
ausgebildet, haben
viel Erfahrung und
arbeiten mit den
Sie behandelnden
Ärzten eng
zusammen.

Design Firm **Joe Bloggs Design**
Art Director **Bushra Ahmed**
Designer **Vicky Kay**
Client **Joe Bloggs Clothing Co.**
Tools **Macintosh, Adobe Photoshop, QuarkXPress**
Paper/Printing **Outer sleeve: 350 gm; Inner sleeve: 250 gm/Offset printing**

The self-promotional catalogue for Spring/Summer '97 was developed from an innovative idea to promote the rejuvenation of the Joe Bloggs metamorphosis.

 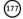

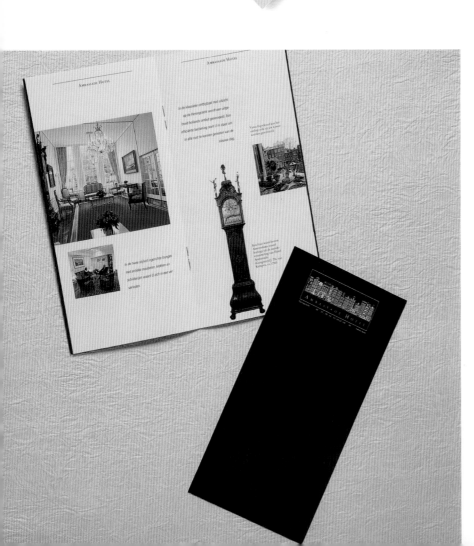

Design Firm **LYNZ-PIX**
All Design **Lyn Mayer**
Copywriter **Lyn Mayer**
Client **Lyn Mayer**
Tools **Adobe Photoshop, grommet maker**
Paper/Printing **10-point cover stock/
Four-color process**

*This piece features a wheel affixed by grommet
to allow for turning. Images for the wheel were
prepared in Photoshop.*

▲

◄

Design Firm **Buttgereit and Heidenreich,
Kommunikationsdesign**
All Design **Wolfram Heidenreich, Michael Buttgereit**
Copywriters **Wolfram Heidenreich, Michael Buttgereit**
Client **Ambassade Hotel, Amsterdam**
Tools **Macintosh**
Paper/Printing **Coated paper/Four-color process**

*This image brochure for a hotel was designed so that its guests
can easily stow it away in their luggage or coats. Modernity and
service meet the tradition of the baroque-style houses in the cen-
ter of Amsterdam.*

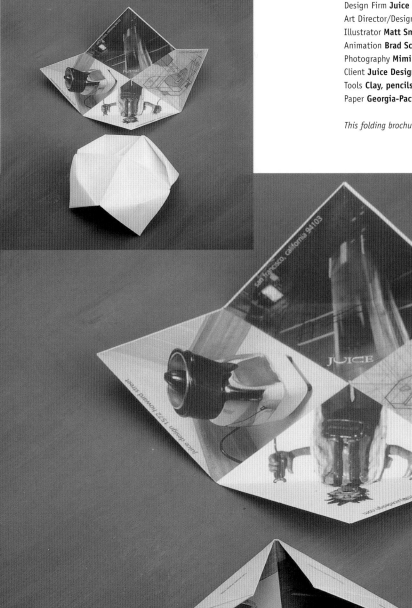

Design Firm **Juice Design**
Art Director/Designer **Brett M. Critchlow**
Illustrator **Matt Smialek**
Animation **Brad Schiff**
Photography **Mimi Pajo, Jan Grintz**
Client **Juice Design**
Tools **Clay, pencils, cameras, and computers**
Paper **Georgia-Pacific Nekoosa Solutions 60 lb. Vellum**

This folding brochure was designed to promote all the flavors of Juice's talent.

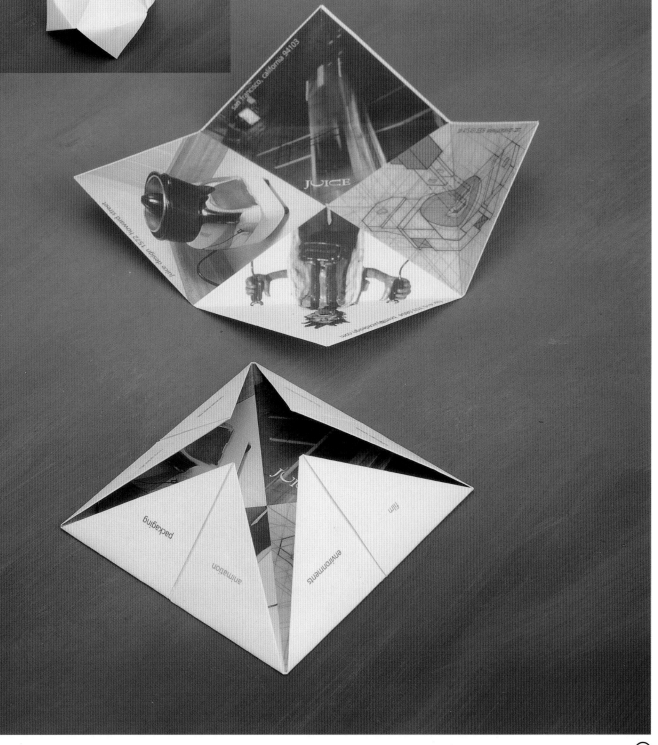

Design Firm
Firehouse 101 Art and Design

Art Director
Kirk Richard Smith

Designers
Marcelle Knittel, Kirk Richard Smith

Illustrators
John Weber, David Butler

Photographers
Stephen Webster, Will Shively, Michael Cougar

Digital Manipulation
Keith Novicki

Client
Retail Planning Associates (RPA)

Copywriter
Kent Rambo

Marketing Directors
Doug Cheeseman, John Bradford, Scott Sommers, Kent Rambo

Tools
Macromedia FreeHand, Adobe Photoshop

Paper/Printing
Zellerbach-Zanders/Six-color offset

This brochure was created to introduce Retail Planning Associates to prospective clients. It guides them through the company, describes the people of RPA, and explains their thought processes regarding the complex and rapidly changing retail marketplace.

Design Firm
Masterline Communications Ltd.
Art Director
Grand So
Designers
Grand So, Raymond Au, Kwong Chi Man
Illustrators
Grand So, Kwong Chi Man
Copywriters
Grand So, Johnson Cheng
Client
Masterline Communications Ltd.
Printing
Offset printing

This brochure introduces the general advertising services provided by the company and presents different advertising and promotional means.

Design Firm **Cornoyer-Hedrick, Inc.**
All Design **Lanie Gotcher**
Copywriter **Cornoyer-Hedrick, Inc. Board**
Tools **QuarkXPress**
Paper/Printing **80 lb. Evergreen Cover Aspen**

This brochure is used as a motivator for internal employees as well as marketing piece for clients. It depicts the firm's mission and purpose. has an accordion fold, and was printed with three colors over one.

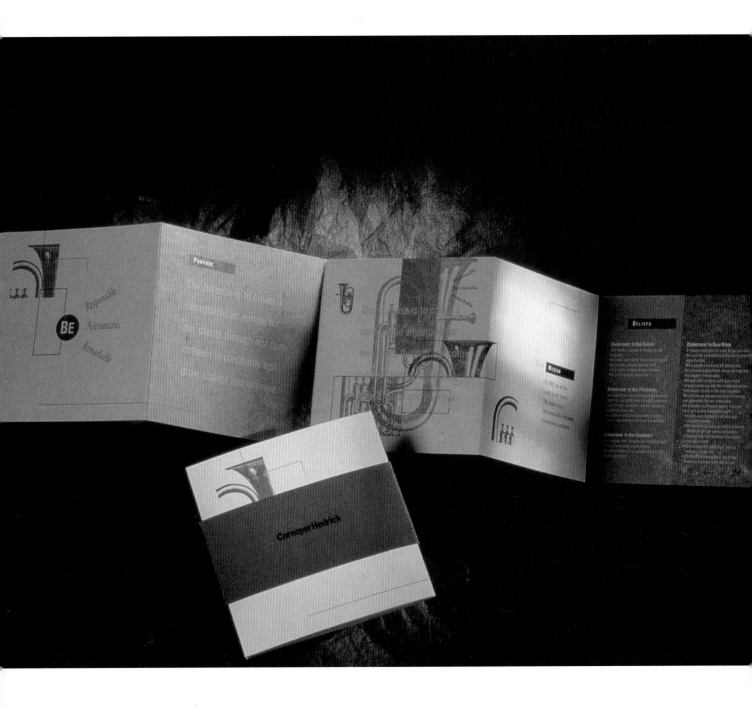

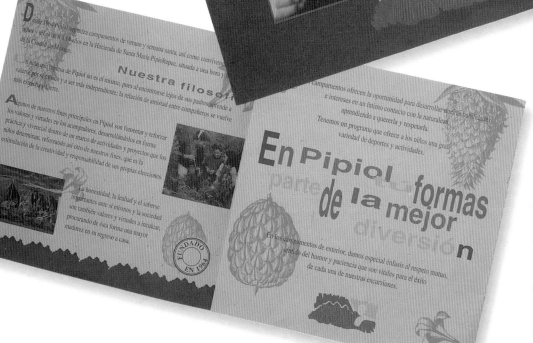

Design Firm
Zappata Designers

Art Director
Ibo Angulo

Designers
Ibo Angulo, Ana Maria Iavalle, and Claudio Anaya

Client
Pipiol Camps

Tools
Macromedia FreeHand, Adobe Photoshop

Paper/Printing
Speckletone Sand/Offset printing

This brochure for a summer-camp organization was a challenge. The main focus of the piece featured the camp's philosophy and was directed toward parents.

Design Firm **Buttgereit and Heidenreich,
Kommunikationsdesign**
All Design **Wolfram Heidenreich, Michael Buttgereit**
Copywriters **Wolfram Heidenreich, Michael Buttgereit**
Client **Lidner, Gemusegrofshander**
Tools **Macintosh**

*This image brochure was developed for use in the higher market
segments (such as international hotels and bank cafeterias).*

Ein Garten
der Wünsche

Markt
geflüster

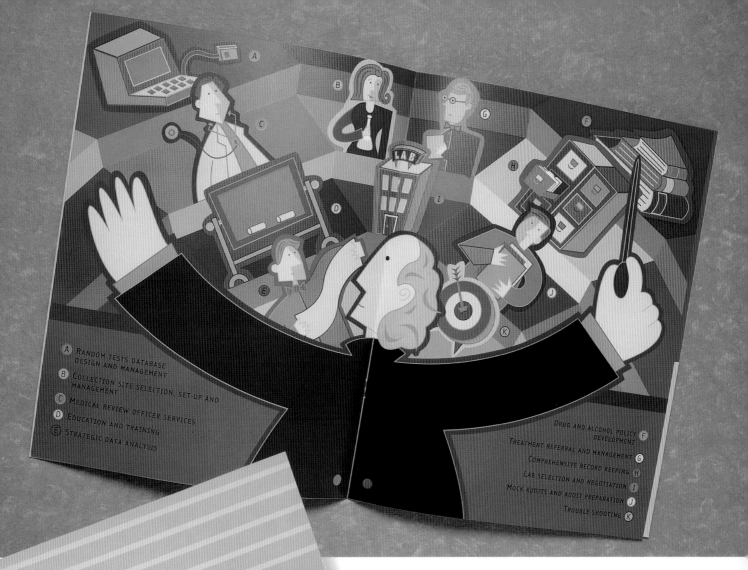

A RANDOM TESTS DATABASE DESIGN AND MANAGEMENT

B COLLECTION SITE SELECTION, SET-UP AND MANAGEMENT

C MEDICAL REVIEW OFFICER SERVICES

D EDUCATION AND TRAINING

E STRATEGIC DATA ANALYSIS

F DRUG AND ALCOHOL POLICY DEVELOPMENT

G TREATMENT REFERRAL AND MANAGEMENT

H COMPREHENSIVE RECORD KEEPING

I LAB SELECTION AND NEGOTIATION

J MOCK AUDITS AND AUDIT PREPARATION

K TROUBLE SHOOTING

Design Firm **Sullivan Perkins**
All Design **Andrea Peterson**
Copywriter **Bill Bancroft**
Client **Assurance Medical, Inc.**
Tools **Macintosh, Adobe Illustrator**
Paper/Printing **Ikonofix**

With limited space to work, it was decided that an entire spread would be devoted to one image rather than feature several smaller images throughout the piece. An orchestra conductor is used as a central visual theme in helping to convey the feeling of the many pieces of the whole.

YOU CAN OBSERVE A LOT JUST BY WATCHING

Yogi Berra

Design Firm **Toni Schowalter Design**
Art Director/Designer **Toni Schowalter**
Illustrator **Bard Martin**
Copywriter **Herma Rosenthal**
Client **Kwasha Lipton**
Tools **Macintosh, QuarkXPress, Adobe Illustrator, Adobe Photoshop**
Paper/Printing **Ikonofix 1/1**

A unique presentation differentiates this brochure from the crowd. The die-cut pages allow for a varied flow, using either the top or bottom pages to outline the capabilities of this consultant firm. Quotes are rendered in Illustrator as individual graphics that work as components of the overall whole. The photography has its own style; the people are portrayed in a relaxed, personal manner.

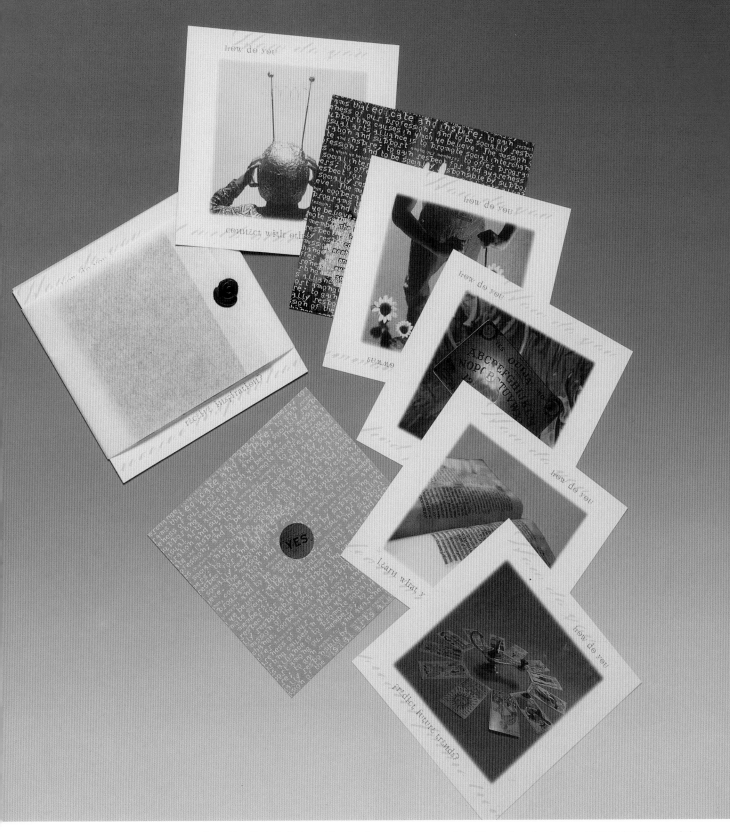

Design Firm **Kimberly Cooke and Ann Freerks**
Designers **Kimberly Cooke, Ann Freerks**
Photographer **Jon Van Allen**
Client **Visual Arts Alliance**
Paper/Printing **Mohawk Navajo/J and A Printing, Inc.**

*Created to recruit members for a non-profit graphic design association,
this brochure features images that depict the search for inspiration.
Pantone Hexachrome inks were used for greater color impact.*

index and
directory